RECOVERING PLACE

COLUMBIA UNIVERSITY PRESS NEW YORK

RECOVERING PLACE

Reflections on Stone Hill

Mark C. Taylor

WITH PHOTOGRAPHS BY MARK C. TAYLOR

Columbia University Press
Publishers Since 1893
New York Chichester, West Sussex
cup.columbia.edu

Library of Congress Cataloging-in-Publication Data
Taylor, Mark C., 1945–
 Recovering place : reflections on Stone Hill / Mark C. Taylor ;
photographs by Mark C. Taylor.
 pages cm
 Includes bibliographical references.
 ISBN 978-0-231-16498-6 (cloth : alk. paper)
 ISBN 978-0-231-53644-8 (e-book)
 1. Place (Philosophy) I. Title.

 B105.P53T39 2014
 818'.603—dc23

 2013027561

Printed in Canada
c 10 9 8 7 6 5 4 3 2 1

This book was published with the support of the Institute
for Religion, Culture, and Public Life at Columbia University,
the Sterling and Francine Clark Art Institute, and Herbert A. Allen.

Cover image: Mark C. Taylor
Cover and book design: Lisa Hamm

For all those who allow time to linger on Stone Hill

He's a real nowhere man,
Sitting in his Nowhere Land,
Making all his plans for nobody.

Doesn't have a point of view,
Knows not where he's going to,
Isn't he a bit like you and me?

JOHN LENNON, "NOWHERE MAN"

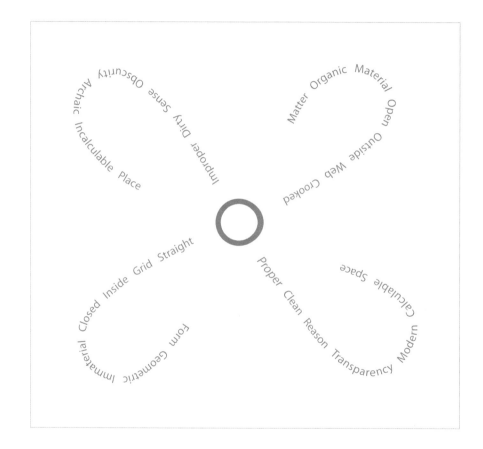

CONTENTS

Introduction 1

Stone Hill 7

Capital 11

Globalization 12

Modern 15

Mobility 16

Displacement 17

Place 18

Non-Place 20

Orientation 21

Posthuman 22

Nihilism 25

Project 26

Philosophy 29

nexus 31

χ 33

God 34

Art 36

Craft 38

Imagination 39

Disfiguring 40

Faults 41

Dawn 42

Night 45

Night Vision 47

Gardens 48

Placement 51

Folly 52

Abstraction 53

Body 54

Flesh 55

Parasite 56

Sense 57

Color 58

Touch 59

Smell 60

Apprehension 61

Thinking 62

Surface 63

Seaming 64

Appearing 65

Human 66

Real 67

Grace 69

Bliss 70

Point 71

Particularity 73

Photographing 74

Wildflowers 76

Infinity 78

Invisibility 79

Holes 80

Shadows 81

Near 82

Tracks 83

Ghosts 84

Not 86

Distraction 87

Boredom 88

Slowness 89

Revelation 91

Fuzzy 92

Compliance 93

Time 94

Complacency 96

Snow 98

Winter 99

Spring 100

Summer 102

Fall 103

Excess 104

Indifference 105

Inhuman 106

Abandonment 107

Cultivation 108

Practice 109

Raking 110

Walking 111

Stones 112

Granite 113

Marble 114

Moraines 115

River Stone 116

Walling 117

Elemental 118

Earth 121

Air 122

Wind 123

Fire 124

Water 125

Rain 126

Ice 127

Wood 128

Forest 129

Flows 130

HardSoft 132

Silence 133

Solitude 134

Waste 135

Pyramid 136

Pit 137

Sign 138

Sacrifice 139

Burial 141

Bones 143

Relics 144

Death 146

Prayer 147

Creativity 149

Economies 150

Waiting 151

Idleness 153

Dwelling 154

Contentment 155

NOTES 157

ACKNOWLEDGMENTS 159

RECOVERING PLACE

INTRODUCTION

MAY 1, 2012. Southeast corner across from my apartment on Broadway and 103rd Street. Starbucks. The name, pirated from *Moby-Dick*, is intended to "evoke the romance of the high seas and the seafaring tradition of the early coffee traders." Who could have anticipated that the Broadway debut of *Moby-Dick* would take place at Starbucks? Herman Melville wrote the greatest American novel in the Berkshire Mountains of western Massachusetts a few miles south of Stone Hill and then retreated to New York City, where he spent the last forty years of his life anonymously working in a customs house and roaming lower Broadway. What would he say about the only character in his novel who is willing to declare Ahab mad lending his name to a global brand?

It is a rare spring day: the locust trees along 103rd are in full bloom; in what is now Riverside Park—where Edgar Allan Poe sat on a stone outcropping while composing lines that became "The Raven"—apple, crab-apple, redbud, and forsythia blossoms announce the end of a long winter. Business at Starbucks is brisk. The coffee shop is crowded with busy patrons scrolling through messages on their iPhones and BlackBerries as they wait in line to buy expensive coffee that many cannot afford, while others are sealed in cells at tables or perched on stools gazing blankly out the window. Starbucks founder Howard Schultz insists that this is no ordinary franchise. In 1983, Schultz traveled to Italy, where, the company Web site reports, he "became captivated with Italian coffee bars and the romance of the coffee experience. He had a vision to bring the Italian coffeehouse tradition back to the United States. A place for conversation and a sense of community. A third place between work and home." With all the fervor of an evangelist, Schultz preaches to prospective customers, "You're the reason we try so hard to make our coffeehouses warm, welcoming places to gather. And you're the one we want to give voice to in our online communities. We'd like to help you have fun, dream big

and connect with the people and ideas that interest you. Because we believe marvelous things happen when you put great coffee and great people together."

But Starbucks is not a nineteenth-century coffeehouse; it is a distinctively contemporary business that tells us much about what is wrong with the world today. Instead of "warm, welcoming," it is sterile and monotonous. The store in my neighborhood is not unique. Heading south on Broadway, there are Starbucks at Ninety-fifth, Ninety-third, Eighty-eighth, Eighty-first, Seventy-fifth, Sixty-third, Sixtieth . . . At latest count, there were 255 Starbucks in Manhattan; 12,781 in the United States; 19,435 worldwide in 58 countries. While the company markets its stores as reflecting local communities, each is virtually identical to the others. When sitting in Starbucks, you have no idea where you are.

Nor do people come together in Starbucks; they congregate but do not communicate. There is little conversation, chatter, or banter; no laughter; mostly repetitious music; the endless noise of commerce and the relentless clicking of keyboards. Rather than forming a community, everyone is alone together, each person locked into a laptop or an iPad, staring blankly at an individual screen and listening to a customized playlist that no one else hears on an iPod that plugs the ears. The only customers talking are speaking into the void to people who are not there, everyone cut off from the surrounding world, cut off from other people, cut off from even themselves. Cells within cells within cells metastasizing in clouds floating above the earth that threaten to turn toxic.

This place is no place.

▫ ▫ ▫

Place is disappearing. The accelerating intersection of globalization, virtualization, and cellularization is transforming the world and human life at an unprecedented rate. The fascination with speed for speed's sake is creating a culture of distraction in which thoughtful reflection and contemplation are all but impossible. These developments are driven by new information and networking technologies that have created a form of global capitalism in which, as Karl Marx predicted, "all that is solid melts into air, all that is holy is profaned." As processes of globalization expand, localization contracts until place virtually disappears in a homogeneous space that is subject to constant surveillance and regulation. While science and technology are literally changing the face of the earth, it is rarely noted that modern and postmodern art prepared the way for this grand transformation. Modernism's veneration of speed, mobility, abstraction, and the new combines with postmodernism's play with free-floating signs that are backed by nothing other than other signs to prefigure the virtualization of life that occurs when the tensions of temporality vanish in the apparent simultaneity of so-called real time. Paradoxically, the more pervasive and invasive Google Earth, GPS, and customized apps become, the less we know where we are. And when we do not know *where* we are, we do not know *who* we are.

...tworking, and media technologies ...also bring losses that should not be ...past time, to slow down and ponder ...it is too late. The guiding thesis of *...ing Pl... ...ons on Stone Hill* is that globalization, virtualization, a... ...arization result in the disappearance of place and the ec... ...of what once seemed real. While these processes appear liberating to many people, they are often profoundly destructive of human relationships as well as the natural world. My wager is that by pausing to dwell on and in a particular place, we may once again know who we are by rediscovering where we are. This is not an exercise in nostalgia but a deliberate attempt to fathom various sedimentations surrounding us that may harbor alternative futures that would allow us to recover ourselves by recovering place. But what is place? Where is place? How does placing occur?

On December 29, 1989, my wife, Dinny; two children, Aaron and Kirsten; and I moved to Stone Hill in the Berkshires of western Massachusetts. The first night, the temperature plummeted to a record minus twenty degrees. When we woke the next morning, the pipes had frozen and we had no water. Fearing that we had made a terrible mistake, I called the person from whom we had bought the house and asked him if he had ever had this problem. He said no and kindly offered to help me. Braving the bitter cold, we ripped the siding off the house and used his blowtorch to heat the pipes until the water started to flow. A few days later, the water

disappeared again. This time, the pump for the well had burned out, and we had to haul up 375 feet of cable to replace it. This was an inauspicious beginning for our sojourn in a place that we have come to love and call home.

One of the many lessons Stone Hill has taught me is that *what* you think is in large measure a function of *where* you think. *Recovering Place* is a work that is placed in every sense of the word. The study where I am writing these words is in a converted barn I designed that overlooks a valley formed by the Taconic Range. On the summer solstice, the sun sets directly across from my window; by the winter solstice, the sun has drifted so far south that I cannot see it. The northern end of Stone Hill is marked by Williams College, where I taught for almost four decades, and the Sterling and Francine Clark Art Institute, which unexpectedly has become a part of this story. Over the years, this place has become a part of my life, and I have become a part of its life. As I have struggled to understand how this has happened, I have learned many lessons that the local can teach the global—lessons about nature and culture, self and world, art and value, and, yes, even lessons about religion and what once was called God. In *Recovering Place*, I have attempted to create a place where others may pause long enough to become mindful of what we tend to overlook in the rush of the everyday.

I never could have anticipated that Stone Hill/*Stone Hill* is where I would end up. Life, Kierkegaard once said, must be lived forward but can only be understood backward. It has been a

circuitous trip: religion, philosophy, literature, art, architecture, technology, networks, media, fashion, finance, economics, biology, painting, photography, steel, stone, earth, bone sculpture, gardens. Without plan or project, one thing just led to another. Looking back, however, there appears to have been something like an invisible hand at work in it all. Hegel was also right when he insisted that "the Owl of Minerva takes flight at twilight." There seems to be a coherence to this journey that I never suspected as it was unfolding.

Recovering Place is not simply a book but a multifaceted volume that represents the extension, perhaps even the culmination, of work I have been doing since I was an undergraduate at Wesleyan University in the 1960s. The philosophers, writers, and artists who initially attracted me were attempting to respond to the displacement caused by early industrial capitalism. Several of the most influential writers roamed the mountains surrounding Stone Hill and composed some of their most important works nearby. Although prescriptions varied, the diagnosis was the same: modernization led to alienation from nature, God, other selves, and even one's own self. When social and political revolution issued in the reign of terror, the major figures who have shaped modern culture and society for more than two centuries turned inward. To overcome alienation, they argued, it is first necessary to change consciousness through religion, art, and philosophy. Far from merely fanciful, the imagination is the means by which self, society, and world can be effectively transformed.

The problems facing us at the [illegible] century are surprisingly similar to t[illegible]teenth century. As industrial capitalism h[illegible] way to financial capitalism, personal, social, political, and economic fragmentation has spread and deepened. Technologies that were supposed to connect and integrate are creating divisions within and among individuals and are deepening the opposition between humanity and the natural world. Globalization leads to a hyper-competitive environment in which any sense of the whole—be it personal, social, or natural—is lost. At this critical moment, perhaps change can come from refiguring for our time and place the insights of past writers, poets, artists, philosophers, and theologians. If this effort is to be effective, it cannot remain disinterested, analytical, and critical but must be committed to developing creative and constructive strategies for dealing with our most urgent problems. We need new maps to help us navigate territories that will become even more perilous in the future. This work is intended to create the possibility of being different by seeing otherwise.

While *Recovering Place* grows directly out of other books I have written, it is a different kind of work because it is not merely a book. As I became more deeply involved with art, media, and technology, I began to appreciate the importance of design for conveying insights. In a series of works ranging from *Imagologies: Media Philosophy* (1994) and *Mystic Bones* (2007) to *Field Notes from Elsewhere: Reflections on Dying and Living* (2009), *Refiguring the Spiritual: Beuys, Barney, Turrell, Goldsworthy* (2012), and

Rewiring the Real: In Conversation with William Gaddis, Richard Powers, Mark Danielewski, and Don DeLillo (2013), style and visual design are integral to the argument of the text. Design is also crucial for two other works that have textual supplements in alternative media: *Hiding* (1997), which is accompanied by a video game, *The Réal, Las Vegas, Nevada*; and *Grave Matters* (2002), which led to a major exhibition at the Massachusetts Museum of Contemporary Art that included grave rubbings, photographs, sculpture, wall art, an interactive CD-ROM, and audio. The Clark Art Institute devoted its symposium in the fall of 2002 to this exhibition.

I learned from the response to these works that to transform awareness, it is necessary to work on multiple levels simultaneously. Concept and percept, thinking and feeling, cognition and affection, theory and practice—not either one or the other, but all at once. Hegel famously insisted that art, religion, and philosophy present the same truth in different ways. The responsibility of the philosopher, he argued, is to translate artistic images and religious representations into philosophical concepts. This insight is correct but one-sided: the translation process is not one-way (image/representation to concept/idea) but must also be reversed (concept/idea to image/representation) in order to create intersecting loops that never close. Far from a thing of the past, as Hegel declared, art helps us envision the future that we might realize. The task of reflection is to apprehend what thought cannot comprehend in figures that only the imagination can trace.

One of the delights of living on Stone Hill is walking along the trail that begins at the edge of our property and ends a mile and a half away at the Clark Art Institute. This path is the remnant of the dirt road that once was the primary connection between Williamstown and the wider world. The point where the trail begins to descend to town is marked by the famous Stone Chair, where generations of college students have long gathered. The back of the chair bears the following inscription:

In Memory of
George Moritz Wahl

George Wahl was born in Germany; did graduate work at the universities of Leipzig, Halle, and Berlin; and taught German at Williams College from 1892 until his death thirty years later. In 1926, the Stone Chair was constructed on the site where he would pause to talk to friends, colleagues, and students on his daily hikes up Stone Hill.

Just beyond the Stone Chair, a gate leads to a beautiful meadow that gradually descends and then gently rises to a stand of white birch. At the top of the hill, one of the most beautiful vistas in New England opens up. In the midst of the Purple Valley, a white church spire rises; nearby, the chapel tower, a gold dome, and a planetarium mark the center of Williams College, where I taught

for thirty-seven years. The artfully designed campus of the Clark Art Institute, with its stunning integration of classical and modern buildings and captivating reflecting pool, marks the northern gateway to Stone Hill.

Over the years, I have walked to this spot in all seasons and at different times of day. The view is always different and never disappoints. I usually pause beneath the birch trees and take time to reflect, while a herd of Guernsey and Holstein cows graze lazily nearby. Sometimes I imagine an impressionist painter with easel, canvas, and brushes, trying to capture the subtle light in a painting to be displayed in the museum below. Stone Hill is a special place where nature, education, religion, and art meet to form a creative nexus.

mct

STONE HILL

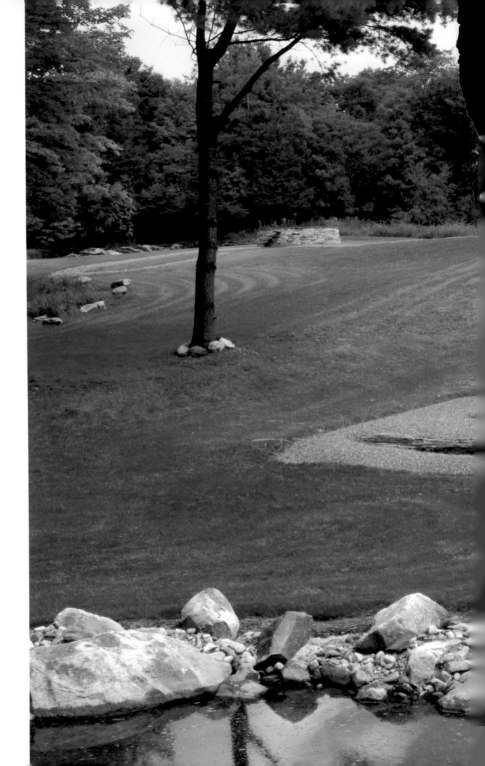

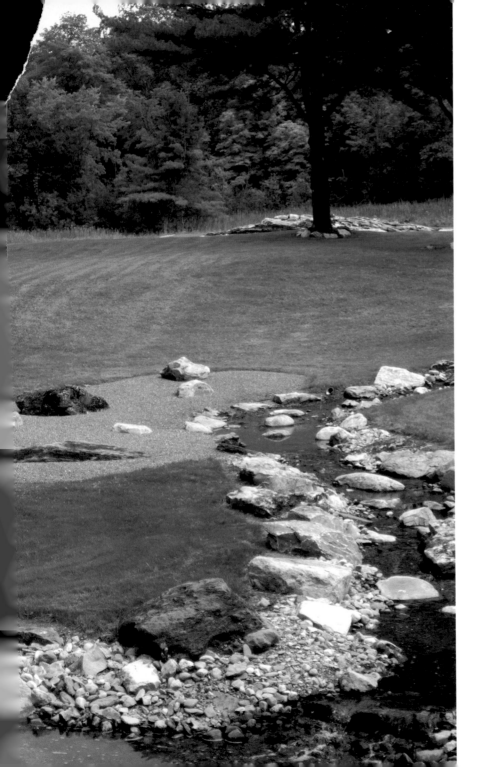

STONE HILL

THIS IS the story of a love affair, a love affair not with a person but with a place—a place that is present here and now and yet, paradoxically, cannot be simply localized: Stone Hill. For many years, Stone Hill has been teaching me the value of place in a world where it seems to be disappearing. Looking back over several decades, I now realize that for me Stone Hill is where the theoretical has become practical; the abstract, concrete; the useful, useless. Artists, writers, and poets are right—life is best understood as an ongoing work of art that not only includes but surpasses the human.

Place, I am learning, is liminal, its draw subliminal—more unconscious than conscious, more affective than cognitive. Lurking between mind and body, the material and the immaterial, place engenders desire that seeks contentment without satisfaction. Place is always marked by an edge that is erotic—earthy, even dirty. This impropriety, which is both attractive and repulsive, is what renders place endlessly fascinating. The love of place unsettles as much as it settles because when love is real, it is always inseparable

from death. Eros and Thanatos are eternally wed, forever bound in a golden braid that joins by separating and separates by joining—not two, not one, but someplace in between.

My love affair with Stone Hill had been going on for more than two decades, when I became restless and left to go to the city. I meant no harm, but while I did not cut my ties, the Hill nonethe-less felt betrayed and responded by becoming even more alluring than ever. Mountains seemed higher; clouds, closer; light, clearer; colors, brighter; darkness, deeper; sounds, sharper; smells, fresher. Gradually, very gradually, I began to notice what had long been hiding in plain sight, and with this revelation the axes of the world quietly shifted ever so slightly.

By leaving, I learned things I would not have learned had I stayed—things about space and place, future and past. It is usually too noisy to notice that something important is slipping away. As real time makes time unreal, place becomes so immaterial that it virtually disappears. Although the hour is late, it is still possible to pause long enough to ponder what is at stake in this loss.

Responsible reflection cannot be rushed—it requires the patience to linger, to listen, perhaps even to languish. I am beginning to realize that I returned to Stone Hill to learn how to die and, by learning how to die, learn how to live anew.

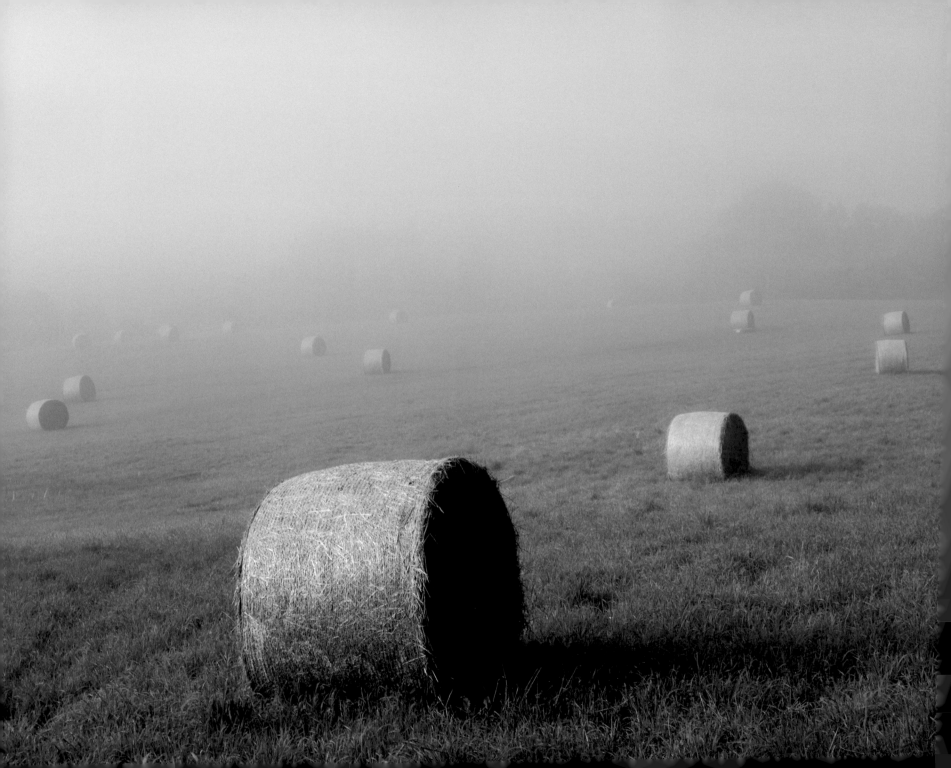

CAPITAL

CAPITAL HAS entered a fourth and, perhaps, final stage:

 Agricultural → Industrial → Consumer → Financial

This development leads to the transformation of both the tokens and the networks of exchange:

 Stuff → Image → Code

There is a discernible trajectory to these changes:

 Concrete → Abstract

 Material → Immaterial

 Real → Virtual

For capital to keep flowing, it must constantly expand. This expansion can take place in three ways: spatially, temporally, and virtually. As markets reach their spatial limits, expansion occurs through the acceleration of the rate of exchange. When all value becomes exchange value, everything is commodified; for the system to prosper, commodities must be exchanged faster and faster. Planned obsolescence becomes a marketing strategy to create desire when there is no need. In the "society of the spectacle," advertising and media dissolve things and even people in images that are cycled and recycled faster and faster. Eventually, currency becomes current—bits of electricity that are exchanged at the speed of light in clouds that can be anywhere. When exchange is thoroughly depersonalized and automated, the society of the spectacle becomes the culture of speculation. Value is no longer measured by work done or things produced or possessed but by strings of digits flowing through global networks. Dematerialization keeps accelerating until reality itself seems to be virtual. But then something unexpected happens—speed produces friction, and the weight of the real returns with a vengeance.

GLOBALIZATION

THE EXPANSION of capital leads to globalization, which leads to the expansion of capital:

GLOBALIZATION

CAPITAL

As networks spread around the world, capital is deterritorialized and the rate of exchange accelerates exponentially. These developments transform time as well as space. Time becomes real time, which is really unreal. When past and future collapse in a present that is virtually real, the ancient dream of simultaneity seems to be technologically realizable.

Globalization transforms space in contradictory ways:

SPACE

PLACE

Space displaces place until the process reverses, and, like the real, place returns at the very moment it seems to be disappearing. The transformation of space by globalization is paradoxical: it both unifies and divides, homogenizes and cellularizes. When things come together, they fall apart; as systems integrate, they disintegrate. The abstract space of exchange creates a monoculture in which payment is instant and exchange seemingly seamless. With the expansion of this abstract, homogeneous space, place contracts. When every mall

has the same stores and every Web site offers the same stuff, here is nowhere, and nowhere is now here.

This expansion harbors a contradiction that proves its own undoing. The condition of the possibility of the system of exchange is also the condition of the impossibility of its closure and completion:

GLOBALIZATION

LOCALIZATION

Global networks presuppose a cellularization that creates pockets of resistance that revive the local and subvert the global. In a world where everywhere is nowhere and nowhere is everywhere, place matters more than ever.

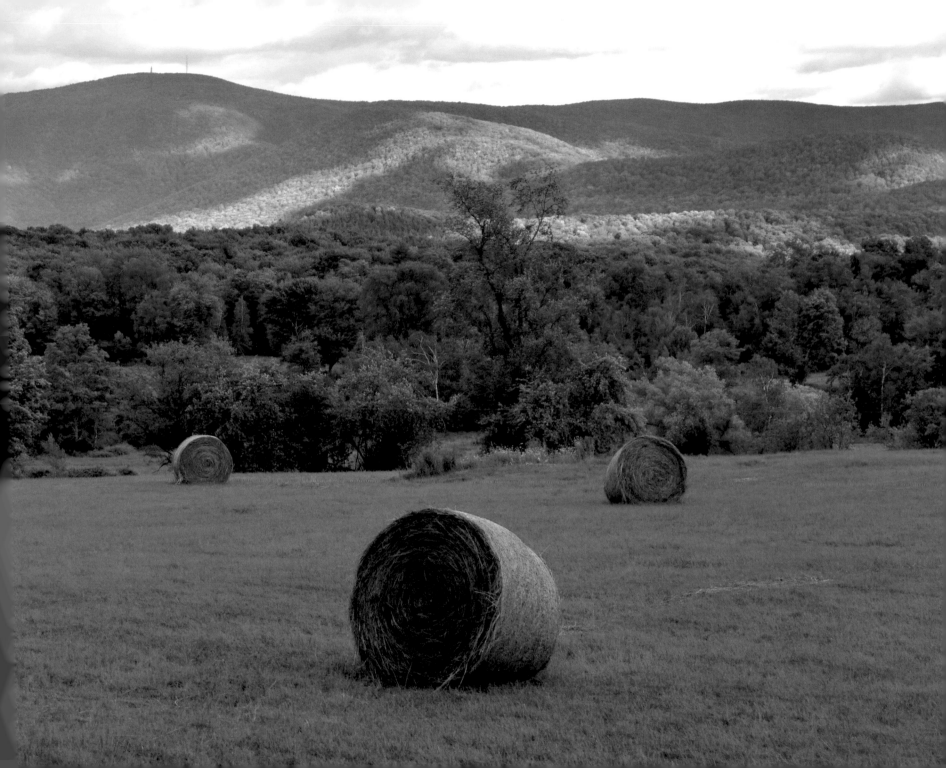

MODERN

Abstraction
Formalization
Mathematization
Mechanization
Geometricization
Universalization

Form over Matter
Geometric over Organic
Immaterial over Material
Closed over Open
Inside over Outside
Grid over Web
Straight over Crooked
Proper over Improper
Clean over Dirty
Reason over Sensibility
Transparency over Opacity
New over Old
Calculable over Incalculable
Space over Place

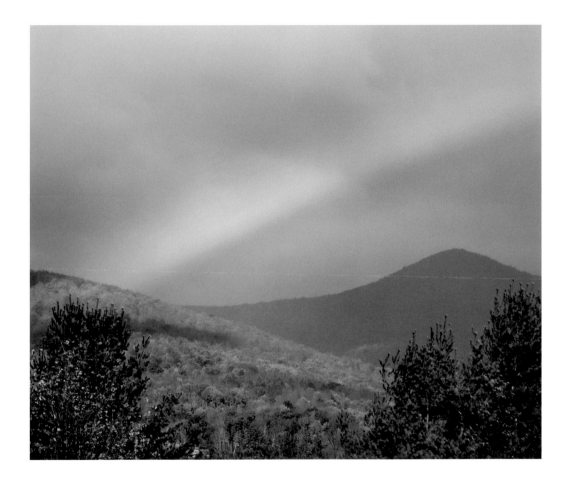

MOBILITY

TO BE modern is to be on the move—everyone and everything is in motion. In this world, to be on the move is to be on the make—mobility is a sign of progress, growth, even sophistication. When we stay in one place for too long, life becomes boring and eventually stultifying. The local is parochial, and if we are to get anywhere in life, home must be left behind.

But not all mobility is the same—for many today, mobility is imposed rather than chosen. Circumstances conspire to uproot people from familiar surroundings and drive them to distant lands in search of food, work, or peace. For those sent into exile, life becomes an endless migration and home a distant memory. For displaced persons, mobility is often an oppressive curse. The farther they roam, the more they are filled with nostalgia and a longing

to return to what once was familiar. Such mobility engenders a transcendental homelessness for which there seems to be no cure.

Having lived on Stone Hill for more than two decades, I have discovered a third mobility, which involves neither modern exile nor postmodern nomadism. This mobility is movement in place that seems to go nowhere. It is possible to travel far in any place, if we are willing to spend time many people think they do not have. Those who linger patiently and attentively in a particular place discover that motion is not always movement and being constantly on the go often gets us nowhere. Sometimes horizons expand when they contract, and the overlooked detail that we were too busy to notice opens new worlds that were hiding in plain sight.

DISPLACEMENT

THE PROGRESSIVE disembodiment of life is creating a new condition—global displacement. Humanity, if there still is such a thing,

is losing its place and its self, detached from its counties and the whole earth. Not only because of its fluctuating movements and its chance felicitous mixtures, begun before the Neolithic age, but because of its new global emigration from space to signs, from the countryside to the image, from languages to codes and from cultures to science. It leaves behind places of work—mines, quarries, rivers, building sites, grassland, ploughed fields—for interiors without windows; sitting and counting, it transforms its muscular body and its numb, calloused fingers into a nervous system that fails to recognize any physical relationship with the space outside. Soon it will no longer inhabit anything but schemas, messages and numbers, all digital. The new humanity without earth, blind now to what we call the real—drugged, or lucid, who can tell? A new earth, without landscape, without bearings.

There can be no new earth or humanity without the old. Disembodied displacement presupposes bodily displacement: people living in squalid conditions so they can labor in mines in distant Africa; young men and women leaving villages to live in oppressive dormitories so they can work twelve-hour shifts in Chinese factories; fathers forsaking their families for years to build mirages in distant deserts; migrants and illegal aliens—yes, *aliens*—sweeping streets, cleaning toilets, harvesting crops, and mowing lawns for people who will not deign to dirty their hands.

The immaterial requires the material—earth without earth is no earth at all. As disembodiment approaches its limit, displacement is displaced. When mines that yield precious metals are exhausted and the Colorado River runs dry, the lights go out in Las Vegas and the global casino shuts down. Like houses built on sand, empires built on silicon inevitably collapse.

PLACE

PLACE IS not a thing but an event that can never be placed precisely. It marks boundaries, yet exceeds every limit. Place is older—infinitely older—than the space it opens. Always defying the logic of non-contradiction, place is the nexus in which being/nonbeing, presence/absence, inside/outside, and here/there simultaneously emerge and withdraw. As such, it is a clearing that clarifies nothing; this is a strange, even uncanny nothing. Nothing ever *takes* place because place is always *given*. Place gives being itself—to be is always already to have been placed, and what has no place is not. And yet place itself does not exist; it remains an immanence that is imminent. Neither nameable nor knowable, place can be apprehended in traces left by its withdrawal from places once deemed holy. Place is a gift we should relinquish reluctantly.

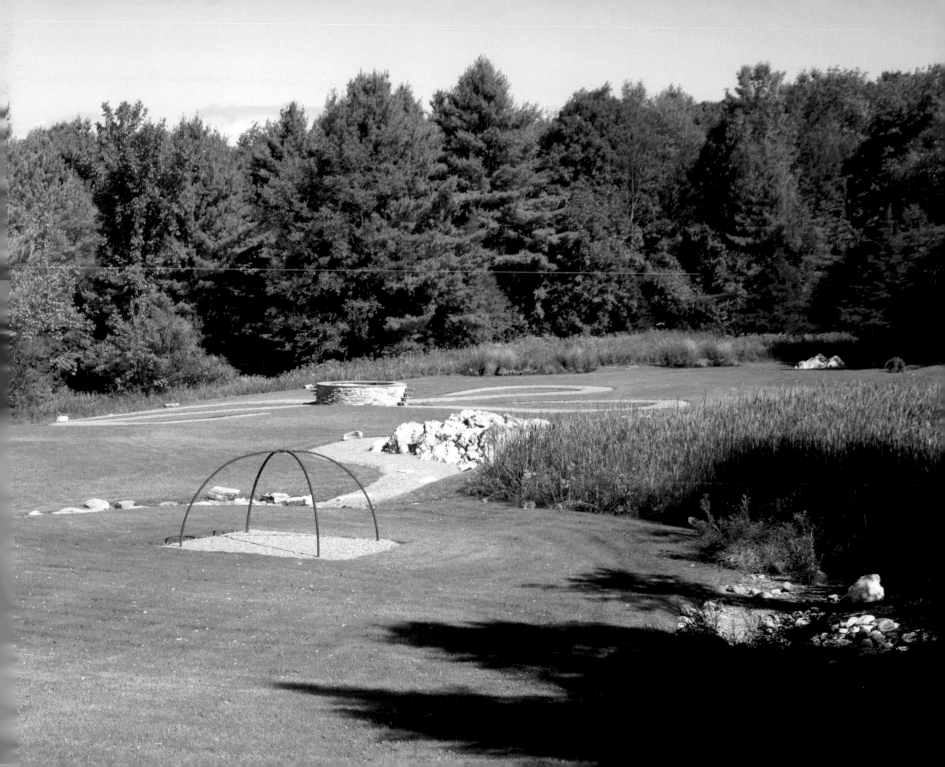

NON-PLACE

PLACE IS being displaced by non-places of errancy, vagrancy, and transit. No longer here but not yet elsewhere, non-places are sites of passage where travelers are constantly in motion but never get anywhere. Transience creates an anonymity that is strange in its familiarity. Though all is perpetually in motion, time stands still to create a cruel parody of eternity. Non-places are where we are apart by being together and together by being apart. Although seemingly local, non-places are all the same and, thus, are really nowhere.

ORIENTATION

DIRECTION IS not the same as orientation. Direction has a goal, an aim, and an end; it tells us how to get away from this place and head somewhere else. When we have no direction, we do not know where we are going. Orientation locates us in a place by establishing coordinates. Heavenly and earthly axes intersect to mark the spot: χ. When we lose orientation, we do not know where we are. And when we do not know where we are, we no longer know who we are.

POSTHUMAN

FROM CAVE to cathedral and temple to laboratory, the means change, but the end remains the same: life eternal. In the era of the posthuman, technology becomes eschatology. Neuropharmacology, genomics, nanobots, therapeutic cloning, somatic gene therapy, neural implants, brain porting, exosomatic memory, brains in vats, downloaded consciousness. Priests in white coats rather than black robes declare that "immortality is within our grasp." All life becomes second life—immaterial, synthetic, virtual. To enter this New Age, we must leave body and earth behind.

Fleshless redemption: mind without body, spirit without flesh, form without matter.

This dream is as ancient as it is modern. Today's neo-Gnostics send complex formulas that promise release from the corruption of the flesh and the filth of matter by reengineering the organism. "The reality," futurists confidently tell us, "is that biology will never be able to match what we are capable of engineering once we fully understand the body's operation." By 2100, life expectancy will be 5000 years, not quite immortality but enough time to find a permanent fix. What goes unnoticed

is that in the relentless struggle to master death, the will to power turns deadly. The quest for immortality is nihilistic—it rejects the world as it is for the sake of a fantasy that will never be real. If the postbiological age ever arrived, it would be the Kingdom of Death.

The question left unasked is: Why? Why this obsession with immortality? It would be comic were it not so lethal. The elixir may turn out to be a *pharmakon*—a cure that is a poison. Perhaps the only thing worse than dying too soon is living too long.

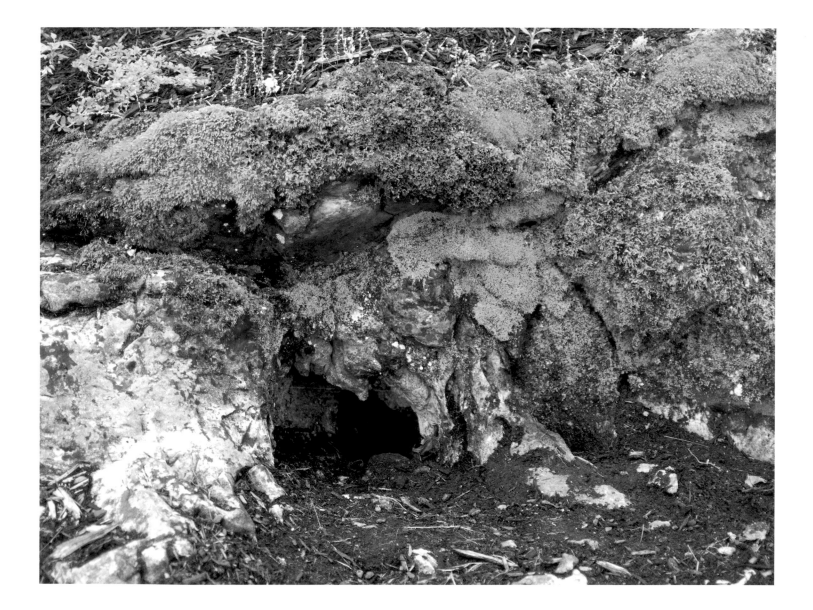

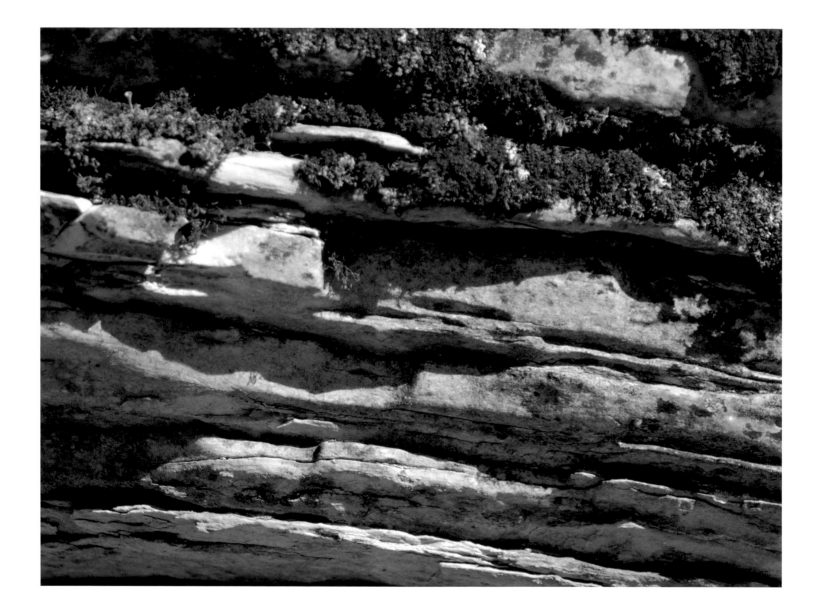

NIHILISM

"NIHILISM STANDS at the door. Whence comes this uncanniest of all guests?" More than a century after Nietzsche posed this prescient question, the answer appears to be that the will to power has turned deadly with the deployment of unfettered technological reason that seeks total control by transforming the world into an instrument for the fulfillment of human desires. Earth, air, fire, water, plants, animals, even other people have become commodified resources that are exploited for human gain. In this game, however, success is failure and winners eventually become losers. The will to mastery inevitably subverts itself by destroying what it cannot live without. As the earth approaches the boiling point, consumption threatens to turn on itself and become all-consuming. Is it possible to give up the will to power by becoming open to what we cannot know and responsive to what we cannot control? If so, perhaps nihilism can be overcome before it is too late. Perhaps.

PROJECT

THIS WORK, which is not a work, is called neχus. It will not have been a project, nor does it have a method. There is no plan, program, or design first envisioned and then progressively realized. I do not know why I began and have no idea how I can end. It is beginning to seem more my undoing than my doing.

A project projects—by calculating everything in advance, it seeks conformity by imposing form designed to create order. Such order is not self-organizing but is imposed from without by an agent who is a manager rather than a creator. For the plan to be effective, every detail must first be defined and then be executed. The fewer the surprises, the more efficient the work and the less time and money wasted. What resists the plan or does not get with the program is removed, repressed, even destroyed.

If not a project, then what? Something like a work that is not work, an oeuvre that is hors d'oeuvre. For an oeuvre really to work, it must expose, not impose; follow, not lead; improvise, not command. Nothing works well without an artful collaboration with chance. Never seeking to dictate or dominate, such work requires time and patience—time to listen carefully and patience to respond thoughtfully. To work responsibly, it is necessary to remain attentive to what is already given. "There is much in being that man cannot master," Heidegger has taught us. "There is but little that comes to be known. What is known remains inexact, what is mastered insecure. What is, is never of our making or even merely the product of our minds, as it might well easily seem." By letting go of projects, we learn that earth is not matter awaiting form; stone is not stuff lacking shape. Earth moves me as much as I move it; I am "just one more way stone has found to be."

PHILOSOPHY

ON STONE HILL, I have learned that *what* we think is in large measure a function of *where* we think. For centuries, philosophers have been thinking indoors, sitting at a desk confined to an office that is a cell. This cell is a sensory-deprivation chamber where the body atrophies and the mind relentlessly pursues the view from nowhere. This style of thinking—and it *is* a style—is allergic to the outside. The only way the outdoors appears to the philosopher is through a window or in Windows. Sealed in his cell, everywhere the philosopher turns, he discovers a mirror in which he sees nothing but his own reflection. It is time for philosophers to listen to poets. Thoreau reports, "When a traveler asked Wordsworth's servant to show him her master's study, she answered, 'Here is his library, but his study is out of doors.'"

To shake philosophy out of its funk, once called its dogmatic slumber, it is necessary to give it legs by forcing it to get up from the desk and venture outdoors. Thought will never be set in motion as long as the thinker is sedentary. Reversing the inward turn with which modern philosophy began, the move outside shatters the mirror of reflection, leaving shards that are unphilosophical fragments.

To think (the) outside, it is necessary to "write" differently. Work can no longer remain bound between covers but must migrate from page to world. The challenge is not to philosophize with a hammer but to think with a shovel, hoe, and rake. We have not begun to think seriously until we get our hands dirty. One day, for reasons I did not understand at the time, I put down my pen and pencil, left my study, picked up my chain saw, and started to clear the land that has become this work. Only then did real thinking begin.

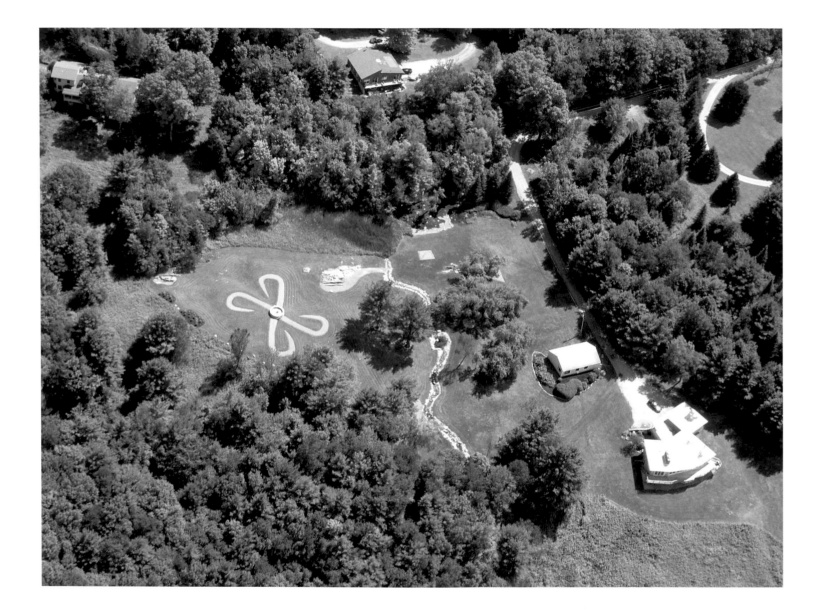

ne𝒳us

Binding—Unbinding—Double Binding

ne𝒳us: the bond, link, or tie existing between members of a group
or series; a means of connection between things
 Latin, from *nextere* (past participle, *nexus*), to bind, connect
 Ned, to bind, tie
 Latin, *nodus*, a knot, node

Abstract/Concrete, Active/Passive, Agitation/Stillness, Ancient/
Modern, Apollo/Dionysus, Appearance/Essence, Archaic/Post-
modern, Articulate/Inarticulate, Artificial/Natural, Autonomy/
Entanglement, Awaiting/Waiting, Balance/Imbalance, Before/
Behind, Beginning/Origin, Beside/Between, Binding/Unbinding,
Bone/Flesh, Business/Leisure, Calculable/Incalculable, Care/
Careless, Clean/Dirty, Clearing/Forest, Closed/Open, Closure/
Disclosure, Comprehension/Apprehension, Concealing/
Revealing, Conceptual/Sensible, Concern/Indifference, Conserve/
Waste, Control/Release, Death/Life, Debt/Gift, Depression/
Elevation, Depression/Euphoria, Destructive/Creative,
Deterritorialization/Reterritorialization, Discontentment/
Contentment, Disembodiment/Embodiment, Displacement/
Place, Disproportion/Proportion, Dissipation/Integration, Distant/
Proximate, Distraction/Concentration, Draw/Withdraw, Dusk/
Dawn, Elements/Elemental, Emptiness/Fullness, Exile/Return,
Expansion/Contraction, Expectation/Surprise, Explicit/Allusive,
Expose/Envelop, Exterior/Interior, Fake/Real, Familiar/Strange,
Figure/Disfigure, Fixed/Fluid, Forgetting/Remembering, Form/
Deform, Form/Inform, Form/Matter, Freedom/Necessity, Frugality/
Extravagance, Global/Local, God/Goddess, God/Sacred, Gravity/
Levity, Grid/Web, Ground/Abyss, Hard/Soft, Heaven/Earth, Hoard/
Spend, Homeless/Home, Human/Inhuman, Identity/Difference,
Immense/Minuscule, Immortal/Mortal, Impatience/Patience,
Impermanent/Permanent, Inanimate/Animate, Inauthentic/
Authentic, Infinite/Infinitesimal, Inside/Outside, Intentional/
Accidental, Isolation/Solitude, Light/Dark, Line/Curve, Location/
Dislocation, Machinic/Organic, Manageable/Unmanageable,
Mediation/Immediacy, Memorial/Immemorial, Mind/Body,
Mindlessness/Mindfulness, Mobility/Immobility, *Morphe/Hyle*,
Movement/Rest, Noise/Silence, Non-Place/Place, One/Many, Order/
Chaos, Orderly/Disorderly, Ostentatious/Reticent, Pain/Pleasure,
Personal/Anonymous, Plenum/Void, Position/Disposition,
Possibility/Impossibility, Predictability/Unpredictability, Present/

Past, Profane/Sacred, Purity/Impurity, Purposeful/Purposeless, Quantitative/Qualitative, Regular/Irregular, Reveal/Conceal, Rigid/Flexible, Rough/Smooth, Run/Walk, Sacrifice/Offering, Safety/Danger, Saving/Spending, Security/Insecurity, Settling/Unsettling, Sight/Touch, Site/Parasite, Sky/Earth, Space/Place, Space/Time, Speed/Slowness, Surf/Dwell, Surface/Depth, Theory/Practice, There/Here, Thing/Nothing, Thinking/Acting, Thrift/Prodigality, Transparency/Obscurity, Unfolding/Folding, Universal/Particular, Unreal/Real, Veiling/Unveiling, Vertical/Horizontal, Visible/Invisible, Work/Idleness, Works/Grace, World/Horizon

⊡ ⊡ ⊡

The χ of neχus figures a knot of knots, a node of nodes that opens and closes the space where (the) all arises and passes away. A neχus places, and place is a neχus that is a neχus of neχuses. As such, place is always an interplace where things come together by being held apart and mingle without mixing. neχus eludes the logic of opposition and subverts the principle of non-contradiction; it is—but, of course, the neχus does not precisely exist—the matrix of all the polarities between which life is forever suspended. An ever-expanding web, the neχus inscribes a condition of nodality in which knots of knots bind, unbind, and rebind loops within loops where the old withdraws and the new emerges. Analysis unties knots and short-circuits nodes; thinking knots reflection in tangled webs that have neither center nor end.

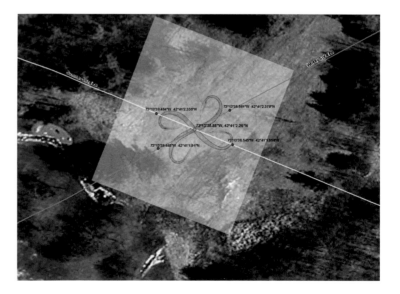

𝒳

𝒳 MARKS (the) place—the crossroads, site of a crossing and double-crossing through which meaning both emerges and is eclipsed. "Chiasma" derives from the Greek *khiázein*, which means "to shape like the letter χ."

When the word is at stake, the chiasmus is a figure of speech in which clauses are reversed. The simplest form of this rhetorical device has the structure *abba*, where the letters stand for grammar, words, or meaning. When the body is at stake, the chiasma is the crossing or intersection of two tracks of nerves or ligaments and the point of contact between homologous chromatids.

But the arms of 𝒳 extend ever farther to create the chiasmic structure of implication. At this intersection, opposites fold into each other in such a way that everything seems to be turned inside out and outside in. This double enfoldment is the re-*pli*-cation or refolding (*plier*, to fold) of opposites. The reversibility of the chiasmus ensures that neither pole in the relationship dominates the other. This structure of implication constitutes what Merleau-Ponty calls the "universal flesh of the world," which is the tissue that forms the com-*pli*-cated milieu of everything that exists.

When the embodied word is at stake, incarnation is the universal flesh that figures, disfigures, and refigures life universal. In a calculus impossible to calculate, 𝒳 figures ABBA becoming flesh. 𝒳 = Christ.

GOD

WHAT IF God were place—not *a* place but place/placing as such? After all, the Hebrew Makom, the name of God, means "Place." If God were place, the disappearance of place would be the death of God. And, of course, vice versa. Perhaps this is the madman's point:

"Whither is God?" he cried; "I will tell you. *We have killed him*—you and I. All of us are his murderers. But how did we do this? How could we drink up the sea? Who gave us the sponge to wipe away the entire horizon? What were we doing when we unchained this earth from its sun? Whither is it moving now? Whither are we moving? Away from all suns? Are we not plunging continually? Backward, sideward, forward, in all directions? Is there any up or down? Are we not straying as though through an infinite nothing? Do we not feel the breath of empty space? Has it not become colder? Is not night continually closing in on us?"

Without any horizon, there is no place; without place, we know neither where nor who we are. If the disappearance of place is the death of God, the recovery of place may be the return of God. And with this return, it may once again be possible to know who we are by knowing where we are.

ART

DEED PRECEDES WORD: the practice of art is the theory of life. Far from a limited activity, art is infinite, though its occurrence is always local. The in-finity of the work of art is the unending process of its own production. The work (verb) of art is the creative activity through which particular works (noun) emerge. Art takes place by giving place to everything that is. As the endless figuring of figure and forming of form, art reproduces itself in all its productions. Like life, art is purposeless or has no purpose other than itself. The function of art is not, as many have long insisted, the transcendence of mere existence but the timely exposure to it. What remains in the absence of the creator is an infinite creative process, which, in Wallace Stevens's words, is "a permanence composed of impermanence." nexus, I am slowly coming to realize, will never be complete, and one day Stone Hill will consume this work I once thought was my own. With this awareness, Nietzsche's question becomes all the more urgent: "Can we remove the idea of a goal from the process and then affirm the process in spite of this?"

CRAFT

CRAFT CAN be fine art. Traditionally anonymous, craft, unlike so-called fine art, is more about the art than the artist. It is not the work of genius but the product of skill cultivated over many years of apprenticeship. The craftsman is more concerned to make it right than to make it new. His work is deliberate and patient rather than spontaneous and improvisational. Masters teach apprentices ancient lessons to be passed on to future generations of students. Since the hand is essential to craft in a way that it is not for much contemporary art, the craftsman never allows others to complete his work. Although he never signs his art, the imprint of his hand is unmistakable.

IMAGINATION

EVERYTHING THAT exists emerges in and through the process of figuring. The imagination puts figures in play by tracing a margin that bestows identity by defining difference. Human creativity is forever surrounded by a creativity far greater than itself. Philosophers and theologians have had it wrong for centuries—God is not the creator; creativity is God. The good news is that creativity is embodied, even incarnate, whenever and wherever figuring occurs. Never limited to or by the human imagination, creativity is at work throughout the cosmos—from the lowest to the highest, from the inanimate to the animate. Divine and human, mind and world: not one, not two. Far from unreal, the imagination is the real in the process of formation.

DISFIGURING

FIGURES AND FORMS are inevitably disfigured. Discourse, Kierkegaard and Freud have taught us, is always indirect, even—perhaps especially—when it claims to be straightforward. Language is shadowed, strained, soiled by what it always leaves out. Forms are fractured, fissured, fragmented by what they necessarily include but can neither contain nor incorporate. By making a virtue of this necessity, disfiguring opens us to what we persistently overlook and deliberately strain to avoid.

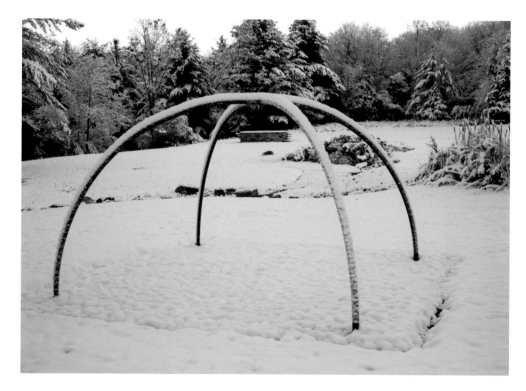

FAULTS

WHAT IF all forms are faulty: fractured, fissured, fragmented? open rather than closed? imperfect, not perfect? incomplete instead of complete? perhaps perfect in their imperfection, complete in their incompletion?

Forms that seem pure and proper are always tainted, even dirty; far from defects, such faults make forms viable. If forms are living rather than dead, they cannot be closed but must be cleaved in ways that allow flows to circulate freely. Vital forms are worldly rather than otherworldly, immanent rather than transcendent—they emerge within the rifts and drifts of elements. While endlessly figuring shifty patterns, faulty forms leave gaps that cannot be figured. These unfigurable openings give life (a) chance.

DAWN

DAWN SLOWLY breaks on the Berkshire Mountains, gradually dispelling lingering darkness. The most intriguing moment in this eternal drama is not when the sun's rays first touch the hills but the instant just before dawn when all of what will be creation hovers on the edge of emergence. It is never clear whether light makes the mountains visible or the mountains make light discernible. In the twinkling of an eye, betwixt and between not appearing and appearing, all things seem possible. Such is the hope of dawn.

But this moment never lasts, for it appears only by disappearing. As soon as light falls on the mountaintop, it begins a gradual descent to the valley below. If we are patient, the eye can glimpse the sun's movement in the steady withdrawal of shadows. But light is never merely light, for illumination creates a residual obscurity more impenetrable than the darkness it displaces but does not erase.

On Stone Hill, dawn's light is never the same—it changes by the day, with the season, even in each moment. There is a texture to light that allows—no, requires—the tissue of vision to be constantly woven anew. Scrims settle on the eye like a mountain mist that creates sensibilities that no word or deed can disperse. Colors become moods, moods colors: the blue and gray of winter, the green and lavender of spring, the red and yellow of summer, the umber and amber of fall. This play of shifting light on hills creates an ethereal yet palpable aura that pervades the body and transforms the mind.

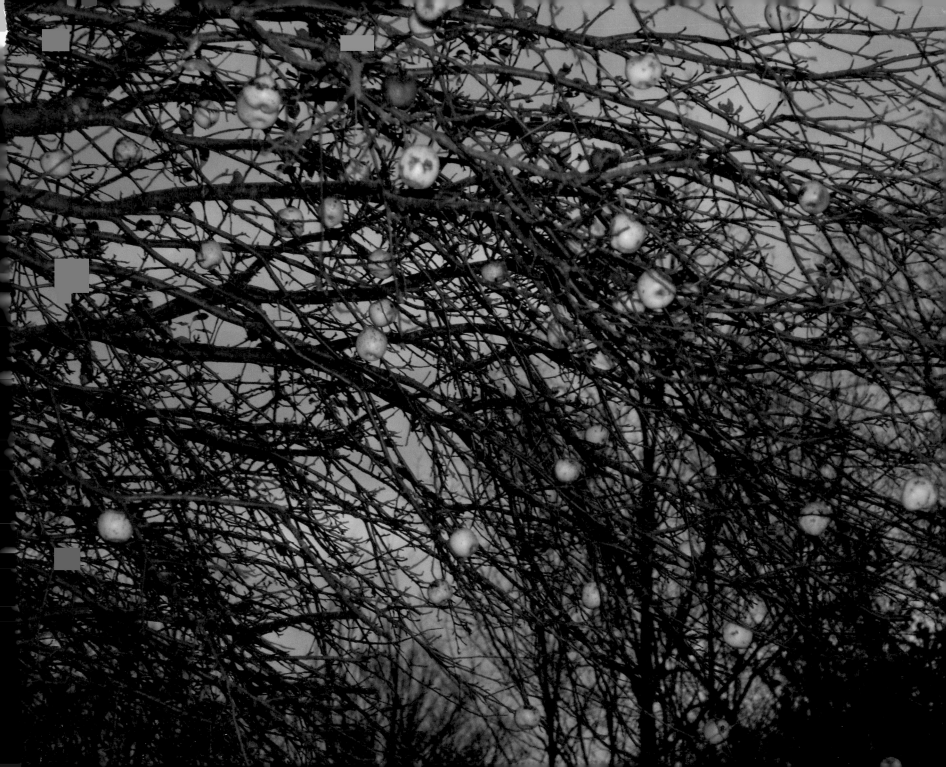

NIGHT

THERE IS not one night; there are two. The first night is the night, opposite of day, which is familiar to everyone. At the end of a long day, we welcome this night and look forward to the renewal it brings. The other night is within as well as beyond what we ordinarily know as day and night, Far from familiar, it is forever strange; never reassuring, it is endlessly fascinating. If day marks the beginning in which light dawns ever anew, the night beyond night is the origin from which day and night emerge and to which they return. Neither light nor dark but something in between, the other night is the realm where shades wander and drift but never settle. The darkness of this netherworld cannot be dispersed. The light of reason tries but always fails to penetrate the other night. Shades haunt our world, leaving nothing clear or precise; if they have a logic, it is fuzzy. The apprehension of shades can occur day or night, in light or darkness, like a faint shadow we barely glimpse.

This strange night gives no rest, even when we are asleep. It is profound but without depth, utterly superficial yet fathomless, extraordinary because so ordinary. While never seen, the night beyond night can be heard in an endless murmur that is indistinguishable from silence. The patterns, rhythms, routines of daily life seem fashioned to silence this silence, but every strategy fails. I never really understood Wallace Stevens's poem "The Snow Man" until I lived on Stone Hill. If someone were to ask what is so disturbing about the other night, I would answer, the "nothing that is not there and the nothing that is."

NIGHT VISION

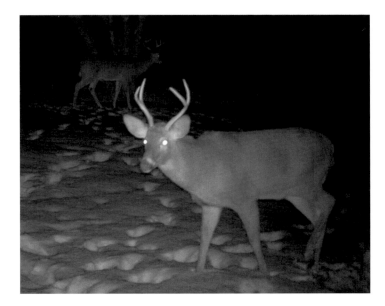

NIGHTS ON Stone Hill are so dark that you see nothing. The depth of this darkness makes sounds more vivid. If you have not heard coyotes howling on crisp autumn nights, you have not fathomed darkness. One night years ago, I heard coyotes shrieking near the house; but by the time I cast the floodlight on the field, they were gone. The next morning, our cat did not return.

Determined to see what I cannot see, I bought an infrared, motion-sensitive camera to take photographs at night. Night after night, I carefully mounted the camera on a tree and scattered bones and meat scraps to tempt coyotes. Each morning, I retrieved the camera and checked the images: deer, foxes, skunks, raccoons, turkeys, crows—but never coyotes. There is a reason the people who once roamed this hill believed that the coyote is a trickster.

Then early one morning while I was reading at my desk in the barn, I turned my eyes to the edge of the field, and there, staring straight at me, was a large coyote. Our eyes locked, and neither of us moved for several minutes; we both knew that we already knew each other. As I groped for my camera, he stood motionless, as if posing for me. Just after I tripped the shutter, the coyote vanished in the high grass. I have never seen him again, but I hear him howl at night and now he knows that I hear him.

GARDENS

"GARDENS ARE as much an intellectual space as the library." This is in large part because gardening is a form of writing. Hoes and rakes are pencils and pens cultivating furrows that are rarely straight. Each garden has its own grammar, vocabulary, and style. Trees, shrubs, and bushes frame the work; herbs and flowers—some annuals, others perennials—provide the words; placement and arrangement create the style. Why one shrub or tree is right and another wrong, one place is right and another wrong remains a mystery. The beauty of a garden is not only how it looks but also how it feels and even smells. The aroma of plants after rain, of newly turned soil, and of fresh bark lingers long after vision has faded.

Most intriguing of all are rock gardens, not because of what they show but because of what they hide. The inorganic and the organic become not two, not one. Mountains, islands, and continents rise from rivers, lakes, and seas. Carefully placed rocks show by hiding—never completely present, they emerge from and return to the depths of the underworld, creating movement without motion, like the mind itself. When it works, the rock garden makes appearing appear by teaching us how to listen to stones. Forms that once seemed inert become fluid and flow through as well as around us. Nothing static. Nothing fixed. Nothing stable. Nothing.

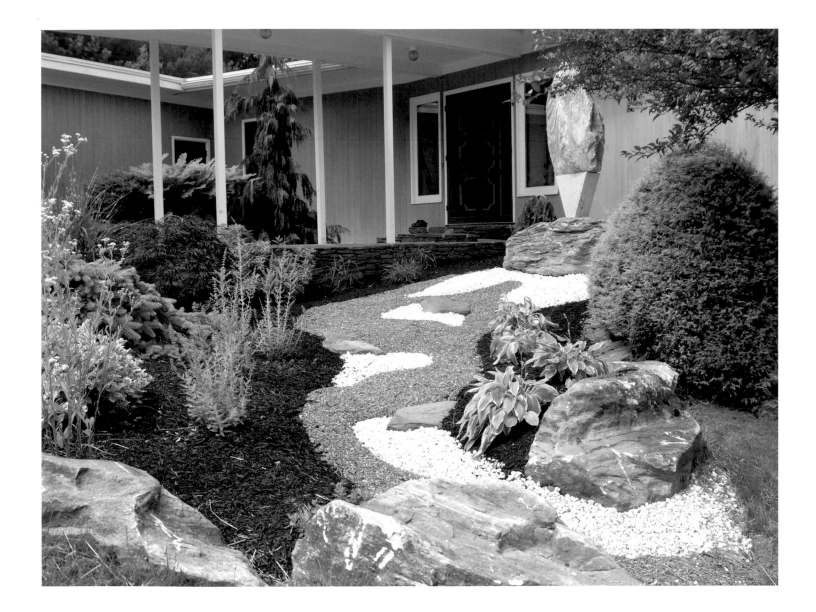

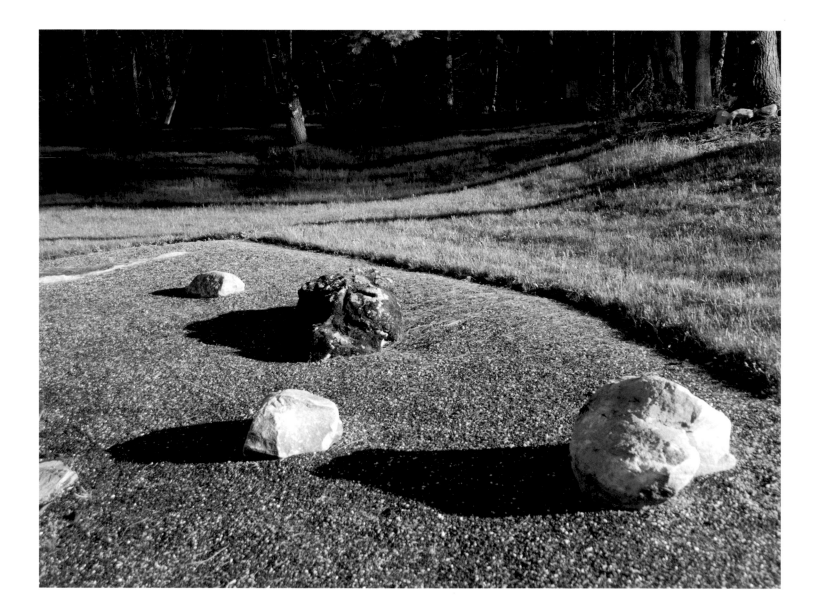

PLACEMENT

THE PLACEMENT of rocks in a garden remains as mysterious as the earth from which they come and to which they return. Odd, never even. Four inches to the left is right; six inches to the right is wrong. Eighteen inches high is too tall; fourteen inches, too short; sixteen inches, just right. Never mix, always match—no limestone with quartz, no marble with granite. Neither too close nor too far, but someplace in between. Why does one placement work and another does not? There is no rational explanation, nor does intuition answer the question. Something else is at work in work—it is almost as if placement were not a decision that I make but an event that occurs through me. In placement, I am; the I is displaced by being placed.

FOLLY

ALL OF this is, of course, (a) folly—a peculiarly contemporary folly. Totally crazy, an obsession bordering on madness. No Roman or Chinese temple, no Gothic towers, no Romantic ruins. There are, however, pyramids, though they are flawed—broken and inverted. It all has become so excessive and extravagant. I did not plan it this way; somehow, things just got out of control. Hours, days, weeks, years of unproductive labor. And for what? It's all useless. Then there is the expense: the books do not balance; there will be no return on this expenditure. But I have no regrets because I have begun to suspect that such folly is as close to wisdom as we can get in this life.

ABSTRACTION

WHAT BEGINS with abstraction and formalization ends with digitization and virtualization: from pyramids, cubes, spheres, and cones to code and polygons. Matter becomes form; stuff becomes code; sense becomes concept; place becomes placeless. The garden is invaded by a machine that is first mechanical and then digital. When numbers are all that count, what can be neither calculated nor coded seems unreal. Abstraction seeks an Archimedean point from which everything can be comprehended. But this ideal can never be realized—forms and codes eventually lose touch with what really matters. "A placeless world," we discover, "is as unthinkable as a bodiless self."

BODY

THERE IS no body without place and no place without body; body and place are extensions of each other—one makes the other what it is. Never complete or proper, the body is leaky, porous, permeable—an open enclosure and enclosed opening. This tissue of tissues is a nexus that channels the circulation of vital elements, at least for a while. These flows always become excessive—they cannot be contained or controlled and, thus, inevitably leave the body messy and dirty. A clean body is a dead body. Inner and outer are folded into each other like a Möbius strip on which it is impossible to know where one begins and the other ends. There is no mind/body, subject/object, self/other split; everything is interconnected, even if not whole. I am, we are the way the world feels, thinks, even becomes itself.

FLESH

FLESH IS not a substance—it is the tissue that holds things in place by weaving them together until all is entwined, enmeshed, sometimes even enamored. Although bodies are always local, flesh is the universal fabric that lends life its texture. Organic and inorganic are woven together in pulsating rhythms that never cease.

PARASITE

Take eat, this is my body broken for you.

WHO IS parasite? Who is host? The cat eats the mouse; the coyote eats the cat; the hunter shoots the coyote that was eating his steer before he could slaughter and eat it.

Parasite ↔ Host ↔ Parasite ↔ Host ↔ Parasite

Every meal is the Last Supper until the earth consumes all.

SENSE

SENSE IS not sensible but is what makes signification and meaning possible. Sense apprehends *that* something is without knowing *what* it is. Neither word nor concept, sense is the blind spot of thinking that clears a place for consciousness while leaving it incomplete. To be sensible is to be exposed to what is never at your disposal because it always arrives from a distance too close to be present. We do not make sense; sense makes us.

COLOR

COLOR BAFFLES. It is neither outside nor inside, neither world nor eye, neither body nor mind, but someplace in between. Neither substance nor accident, it is a constantly changing interactive event. No color can be itself by itself. Where or when does one color end and another begin? Color is (a play of differences that is) always local. Watching constantly changing colors on Stone Hill, I have come to realize that it is not so much that places are colorful but that color is always placed. Color belongs to place as much as place belongs to color.

TOUCH

WE HAVE lost touch with touch. When the real appears virtual, matter no longer seems to matter. Reality loses its gravity, thickness, and depth and becomes a pale shadow of what it once seemed to be. Although this loss may be mourned, it is impossible to return to the real unless the real first returns by touching us. The sense of touch breaks the spell of solipsism by restoring the texture of things. To touch is always already to have been touched—like earth rising to meet an extended hand and leaving its dirty trace as a reminder of what cannot be avoided even when it is forgotten. Places as well as people and gestures can be touching. To be touched by a place is to have all our senses realigned at least for a fleeting moment.

SMELL

THE SCENTS of Stone Hill fill my mind with memories that transport me to times long forgotten. There are people and places whose images I cannot remember but whose smells I recall. When we are deep in thought, an unexpected odor can disrupt concentration yet deepen reflection. Some smells are pleasant—newly cut grass, damp pine needles, freshly turned soil. Others are not—a rotting deer carcass, a skinned fox, a startled skunk. Smell not only recalls the past but also grounds the present and even transports us to the future. If I close my eyes and cover my ears, I can tell the season, sometimes even the time of day, from the smells surrounding me. On late-summer afternoons, I smell storms before I see lightning and hear thunder; on winter mornings, I smell snow hours before it begins to fall. When life becomes virtual, we forget how to smell and lose our nose for the real.

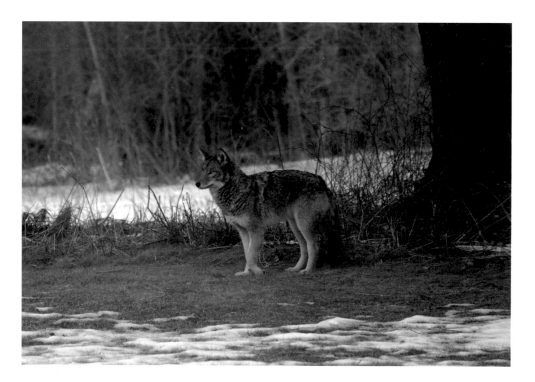

APPREHENSION

WE APPREHEND things we cannot comprehend, and, thus, thinking always remains open to the unexpected. Apprehension is an ambient awareness of a tacit dimension charged with latency. Since boundaries, borders, and limits are always porous, everything is surrounded by a penumbra of obscurity. Apprehension does not seek to grasp but responds to solicitations that can never be anticipated. Neither sensible nor meaningful, what is apprehended forms the matrix in which sense and meaning emerge. Thinking is the aftereffect of apprehension, and this enduring debt leaves us apprehensive.

THINKING

THE THINKING that matters cannot be programmed or calculated. It not merely imposes order but also accepts what is given as given. Thought, therefore, is never original but is always an afterthought of some thing that necessarily eludes its grasp. This thing, which is not precisely a thing, is the real. There is no thought without the real, but the real itself can never be thought. Thus thinking inevitably is surrounded by a cloud of unknowing. Instead of pursuing what can be calculated in advance, real thinking endlessly figures its own impossibility.

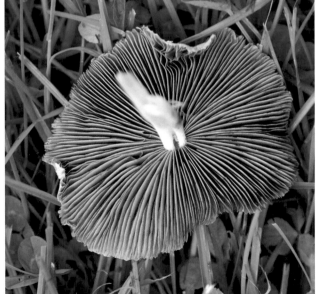

SURFACE

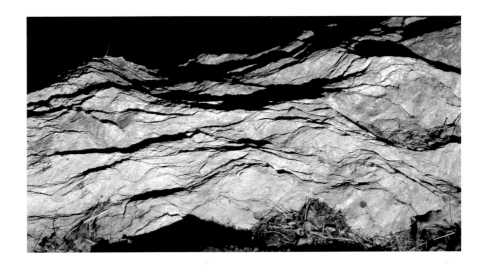

WHEN APPEARANCES are no longer apparent, there is a depth to surface that renders it profound. Scrape away one surface and another emerges, until we eventually realize that it's surface all the way down and all the way in. There is no bottom line to provide certainty, security, safety. Each surface has a new wrinkle that complicates what once seemed obvious. If everything is superficial, the problem is not the absence of meaning but the infinite proliferation of meanings.

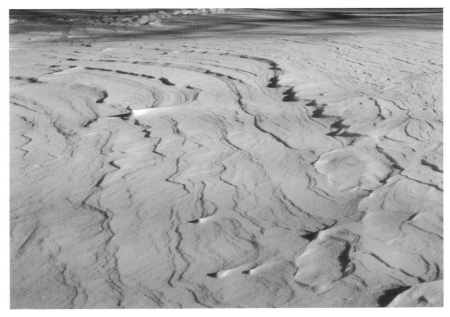

SEAMING

EVERYTHING IS a matter of seaming: con-
necting and disconnecting, matching and
mismatching, coming together and drift-
ing apart—like a tear that does not tear.
Seams mark and re-mark the edge of being
and nonbeing. The more elegant the seam
and tighter the fit, the more graceful the
thing. When seams are carved in stone,
they breathe life into what had long seemed
inert objects. If you listen to the silence of
seams, you can hear the breath of stones.

APPEARING

THERE IS no other world of which this world is a faint shadow, no perfect world from which this world has fallen. Appearances are not apparent—appearing as such is real. Worlds beyond are created by those who cannot bear the reality of this world of appearances. The real is not elsewhere—it is here and now as what is always appearing and disappearing. This is the truth of incarnation.

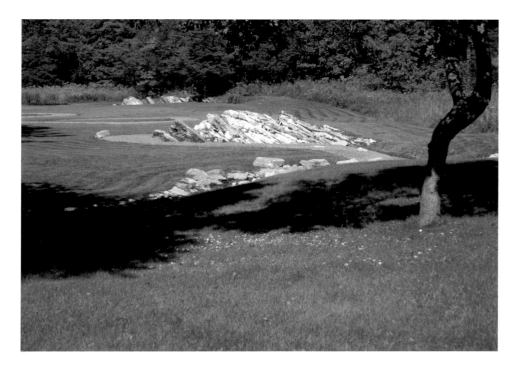

HUMAN

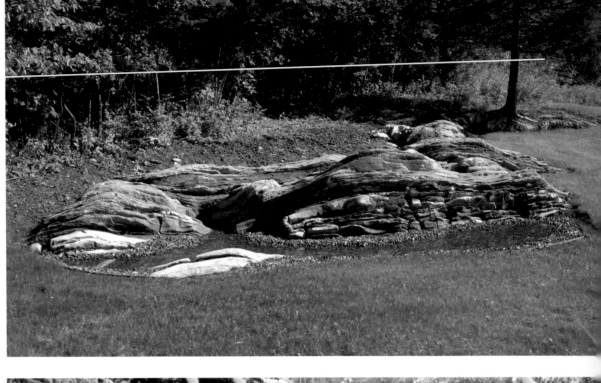

TO BE human is to be mortal, and to be mortal is to be of the earth. "Humanity is not a species; it is a connection with the humus." Humus—earth, ground, soil. But not just any earth; humus is a black organic substance consisting of partially or wholly decayed vegetable matter that produces nutrients that allow plants to grow. The human is the nexus of life and death—never one without the other. Perhaps this is why Kierkegaard insists that "death is a good dancing partner."

With death forever haunting us, the challenges of life should be met with a humility that resists the will to master, control, and dominate. Such humility begins with the acceptance of our common humanity, and this requires embracing death, which is what we finally share. Our time, Heidegger reminds us, "remains destitute not only because God is dead, but because mortals are hardly aware and capable of their own mortality."

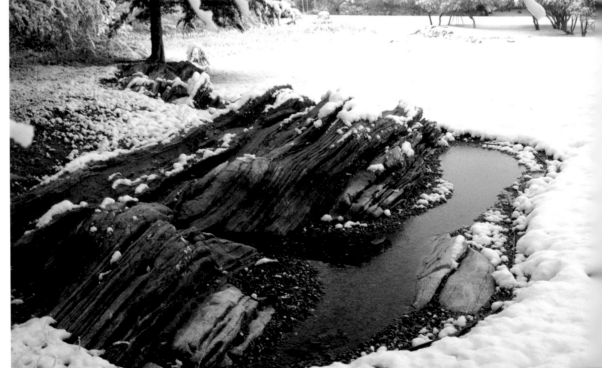

REAL

THE REAL is what remains when I do not
and forever withdraws in my presence.
Resisting my resistance without opposition,
the real is the limit that makes creativity
possible. Thinking is always after the real,
which can never be properly comprehend-
ed, calculated, or controlled.

GRACE

"WHEN NOW and again a stone falls into a place that is utterly inevitable," master craftsman Dan Snow reflects, "I feel I am suddenly standing under a shower of grace. For an instant I become inevitable, too. I share the compatibility that stone finds with stone. If I'm lucky, it happens a lot. Then again, some days it doesn't happen at all. Grace may fall in the next moment or never again. I know only that if I put myself with stone, it may happen again."

Although seemingly inevitable *après coup*, grace is always gratuitous, completely a matter of chance. It cannot be anticipated or earned, nor can the moment of grace be prescribed, programmed, or planned. Arriving as a total surprise, grace turns the world upside down—eternity enters time to disrupt, without displacing, what long had seemed settled. Grace—like a rose, a stone, and even life itself— is without why and, thus, remains forever incomprehensible. If there were a proper response to grace, it would be mute astonishment.

BLISS

"BLISS IS not what *corresponds to* desire (what satisfies it) but what surprises, exceeds, disturbs, deflects it." Like the subtle shades of dawn falling on a mountain seen through the prism of a tiny melting icicle.

POINT

...EVERYTHING begins and ends in a point. Tzimtzum, *Bindu*, Degree Zero. It is a matter of drawing and withdrawing. Point becomes line becomes plane becomes solid becomes plane becomes line becomes point. Expansion and contraction mark the place where placing occurs. The lure of the point is what is always missing . . .

PARTICULARITY

THE SCANDAL of particularity is the delight of place. The particular has an eloquence that the abstract lacks. Such-and-such a place, such-and-such a time. Never repeatable, always new; never the same, always different. The particular is so specific and so fleeting that it must be glimpsed, never grasped. The closer we look, the more we realize that the particular is not set apart; its fingers stretch into its surroundings, whose fingers stretch into it. Nothing is itself by itself; everything is related in an endless play of differences—like ever-shifting hues on an endless spectrum or constantly changing notes on an infinite scale. We cannot see the subtle hues or hear the faint notes of the particular unless we stay in place.

PHOTOGRAPHING

WHAT GIVES when a photograph is taken? Photographing does not produce pictures that represent what is no longer present but creates images that trace the presencing of presence. In the blink of an eye, the photograph exposes appearances as appearing. Place and time intersect in the photograph; for images to be effective, aperture and shutter speed must be carefully calibrated. The tighter the focus, the greater the resolution; the greater the resolution, the deeper the insight into the unfathomable play of surfaces. Even though it is still, the photograph is the medium for the event of appearing. The camera not only registers the visible but exposes the invisible. By increasing the shutter speed, we see what we cannot see, and yet a residue of invisibility always remains. Since the image presents a presenting that is never itself fully present, it remains shrouded by transparent shades that render it obscure. The lingering uncertainty of the image is its draw.

Photographing is an activity that requires passivity; images are not taken or captured but are given, like gifts from an unknowable donor. To receive this gift, we must wait patiently, always remaining open to the unexpected. The eye is never more attentive than when photographing. Waiting attunes the mind to what is fleeting and effervescent. The photograph of life in its passing is not only the mask of death but also the trace of life in its infinitesimal detail and prodigious abundance.

WILDFLOWERS

The rose is without why; it blooms because it blooms.

It pays no attention to itself, asks not whether it is seen.

WITHOUT WHY, without use, without purpose, without end. Uselessness, purposelessness, and endlessness lend wildflowers—and everything else—their beauty. This "without" harbors an absence that is not a void but an excessive fullness. Wildflowers are not planned or planted but are just *there*. Although seeming to have been deliberately designed, their beauty is utterly gratuitous, completely superfluous—a matter of grace that can be accepted only as an inexplicable gift. What makes this gift so baffling is that such ostentatious display is given even in the absence of anyone to receive it. The moment in which the glory of a wildflower is glimpsed always seems purloined, as if we were intrusive voyeurs watching a show designed to remain private.

The closer we look, the deeper and more complex the beauty of wildflowers becomes. Tight focus creates a depth of field, revealing details within details within details—each more astonishing than the last, and all overlooked in the customary haste of daily life. Proper exposure opens the attentive eye to shades of difference never before imagined. Redbud, apple, crab apple, lilac, tulip, daffodil, forsythia, dandelion, phlox, daisy, black-eyed Susan, azalea, rhododendron, laurel, heather, honeysuckle, bleeding heart, goldenrod. Names cease to matter—everything dissolves in a display of color that eludes words. One day, we finally realize that perhaps truth is a wildflower blooming in spring.

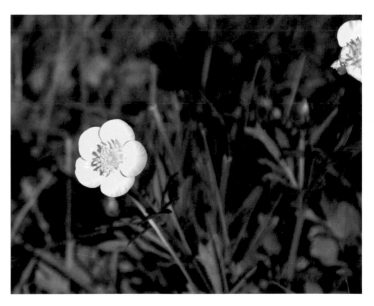

INFINITY

THE INFINITE is not opposed to the finite, nor is it elsewhere—above, below, past, or future. It is always placed (here and now). If it were opposed to the finite, the infinite would not be infinite but would be limited by whatever it does not include. Immeasurably grand and incalculably minute, the infinite is infinitesimal and the infinitesimal is infinite. Always double, the infinite and the finite fold into each other like intersecting Möbius strips whose loops almost meet. What is the value of infinity when it is doubled?

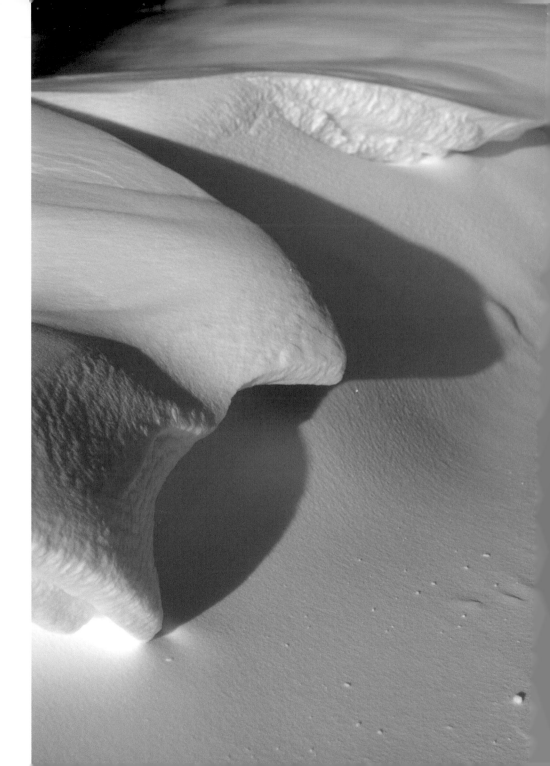

INVISIBILITY

THERE IS no visibility without the invisible
and no invisibility without the visible. The
tear in vision is the opening that simulta-
neously makes sight possible and leaves it
incomplete. What we see is never all we get;
there is always more, and this more, which
is less, is what keeps us coming back again
and again and again. The shadow of invis-
ibility makes the visible both inexhaustible
and infinitely intriguing. When art works,
it reveals the specter of blindness without
which insight is impossible.

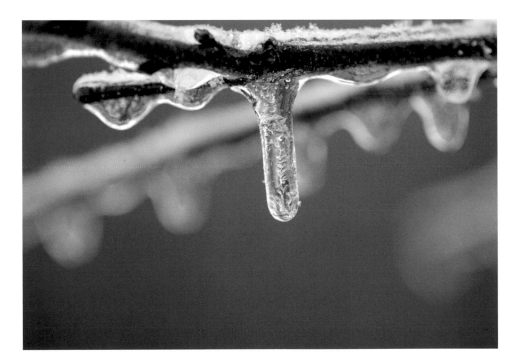

HOLES

HOLES ARE what the pit is about. Stone can never fill the hole because holes place stones as much as stones displace holes. Hole and stone: Which is figure, and which is ground? The oscillation and alternation between stone and hole is the trace of another hole:

The cutting blade of sunlight shaving Africa;
Pipe smoke curling slowly upwards, a cobra's ghost;
The child's black pupil with its coffin shine.
A hole within a hole that's through a hole.

This "hole within a hole that's through a hole" is the pit that is the place of the real.

SHADOWS

SHADOWS ARE shades of difference that lend everything and everybody substance by rendering them double. Duplicity reveals the lingering obscurity in all transparency. The play of the infinite: shadows figuring ground figuring shadows. Is shadow the absence of light or light the absence of shadow? Shadows define the real by tracing the seam between the visible and the invisible.

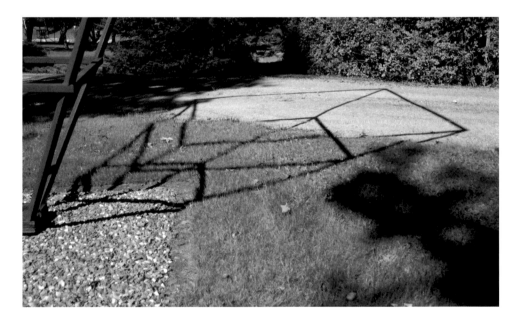

NEAR

WHAT IS near is never present, nor is it absent. It approaches by withdrawing and withdraws by approaching. The near is not opposed to the far; rather, distance is folded into proximity in a knot that cannot be untied. There is an intimacy to nearness that eludes words. Who can speak clearly about what is nearest to her? The closer we draw to the near, the more it slips away; the closer the near draws to us, the more restless we become.

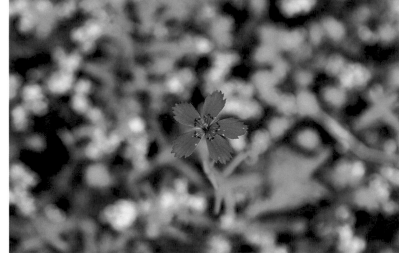

TRACKS

WHERE DO the animals go when winter snow drifts? Deer, bears, coyotes, foxes, rabbits, groundhogs, turkeys—all disappear. But they leave tracks that trace their absence. When the snow is deep, the night is silent, and the woods are still—nothing moves on Stone Hill. Holes are dug deep in the snow, and on some mornings fresh tracks surround them, but the mice, squirrels, and chipmunks are nowhere to be seen. As the creaking and cracking of thawing earth give way to the rush of flowing streams, fresh tracks appear long before the creatures that left them. One night the coyote howls, and at dawn the deer unexpectedly return, looking for apples long buried in snow.

GHOSTS

THE MEMORY of a place is not so much our memory of it as its memory of us. We do not *have* memories; rather, memories surround, invade, and possess us. Never floating freely, memories are bound to a place and borne by ghosts—some holy, some unholy. Although not silent, ghosts never talk to one another. Drifting here and there and looking for someone to haunt, they ceaselessly stir without leaving a trace. Their desire—yes, ghosts do desire—is not to talk to us but to speak through us. Before we realize it, these specters from the land of not draw us into their orbit and take possession of our voices. Our words are no longer our own because we are the hosts of others, both known and unknown. When memories are ghostly, they are never ours but extend to a distant past and beyond to a time before time that is terrifyingly ancient. Spirit does not give us life; we give life to spirits.

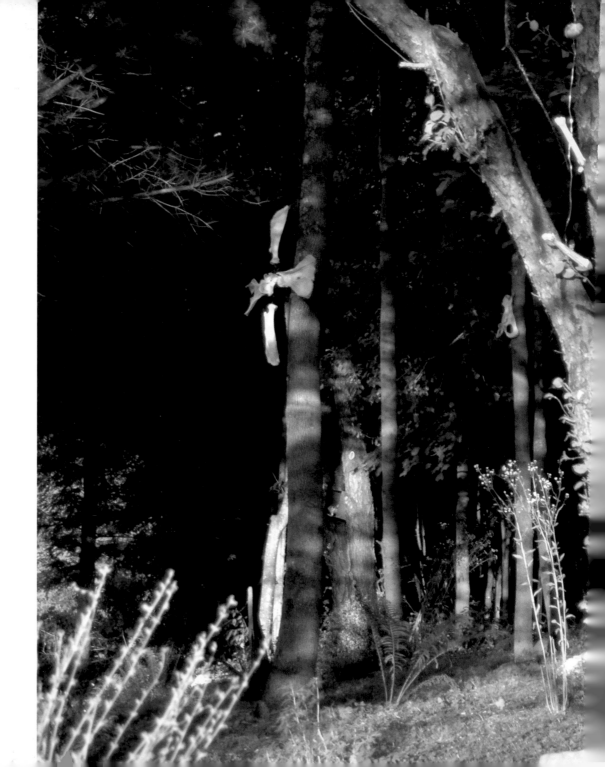

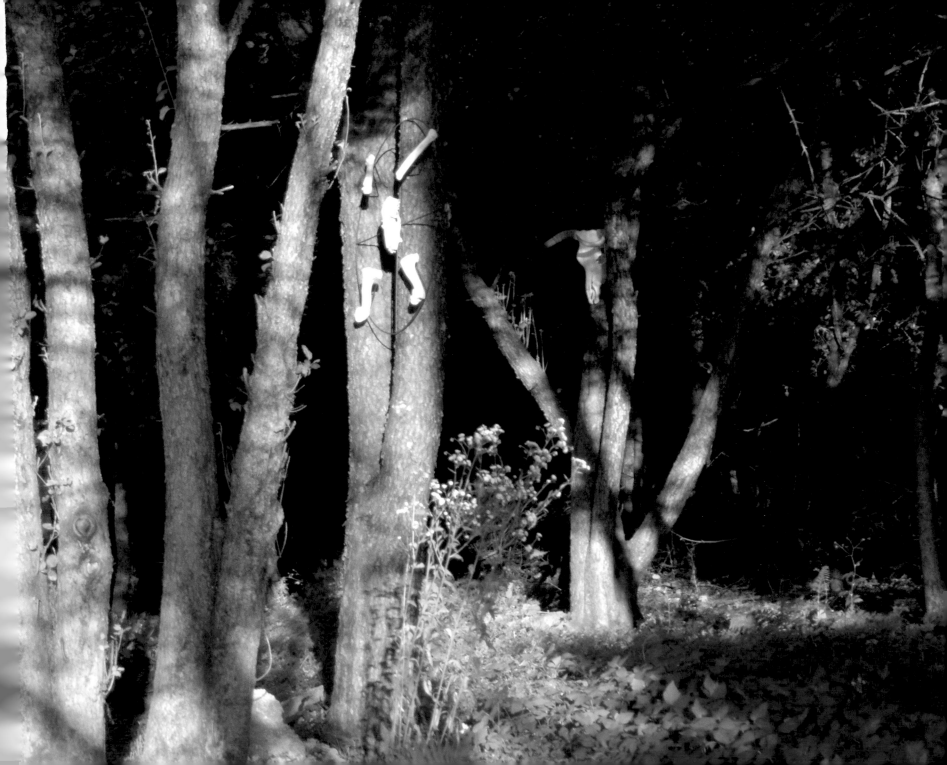

NOT

WHY NOT? Why so many nots? Not this, not that, not any *thing*? The question of the not is older than thought itself, for it is impossible to think without already having thought not. To think not is to think what cannot be thought, which is not the same as not thinking. The not binds thinking to the unthinkable, which marks the limit without which thought is impossible. Real thinking thinks (the) not.

DISTRACTION

WE LIVE in the Age of Distraction, when thoughtful reflection has become almost impossible. Churn and buzz keep mind as well as body constantly in motion, with no place to land. Like water striders skimming across the surface of a pond, we are afraid to stop lest we sink. Fast rather than slow, short rather than long, loud rather than quiet, easy rather than difficult. Chatter does not cease, even if the plug is pulled. When always online, to focus too long or concentrate too hard is to miss the real action. What people most seem to fear is the tedium of the everyday, which is, after all, what life is all about.

BOREDOM

SOME DAYS on Stone Hill are boring—nothing happens, and, thus, nothing matters. But what does it mean for nothing to happen or nothing to matter? When we are bored, time does not just slow down but is suspended—as if eternity had shattered the moment, and the world as a whole slips away. This nothing is not merely the absence of this or that, the lack of what has been or might be there; it is more profound, more elusive, more troubling. The nothing that matters is the void in the midst of everything that renders (the) all meaningless. When nothing matters, nothing happens—what is is, and what is not is not. During periods of boredom, meaning vanishes and does not return until we eventually become bored with boredom.

SLOWNESS

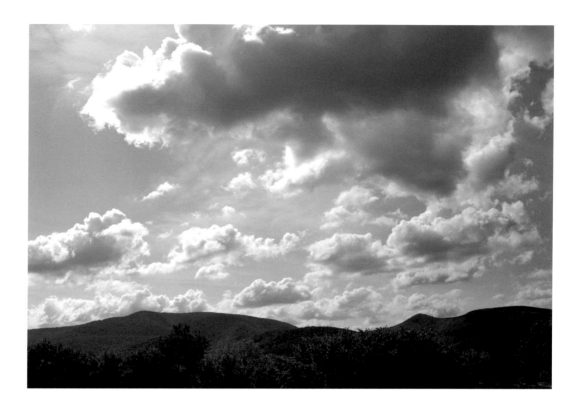

OUR AGE is addicted to speed—not speed for the sake of efficiency, not speed for the sake of productivity, but speed for the sake of speed. According to the gospel of speed, the quick shall inherit the earth. The ever-new new thing creates insatiable desire, even though there is no need. As division infinitely multiplies, nanoseconds create unreal real time. Patience gives way to impatience; delays and deferrals become unbearable. Everything keeps accelerating until we approach escape velocity, which seems to leave the material world behind. At the outer limit of speed, an unexpected transvaluation of values occurs. The faster we go, the less time we have, and in the rush to save time, we inevitably waste it. Eventually, we come to realize that speed distracts from what matters most. The real can be savored only slowly—the most radical thing we can do today is slow down.

REVELATION

THE REAL is hiding in plain sight—like a purloined letter sitting on the mantle or a stone outcropping long covered with moss, grass, weeds, and brush. Showing by hiding, hiding by showing. Strip away the surface, and another surface is folded into depths that are insecure and unfathomable. Being always exceeds manifestation. The rock appears unexpectedly like a monstrous leviathan bursting from the depths of the ancient sea that once filled this valley. Waves are frozen in petrified lines hidden longer than scientists can calculate. Revelation comes not only from the heavens above but also from what has always been near, beneath our feet yet never noticed. A "white hump" covered with barnacles, like Melville's scribblings that appear to be "mysterious ciphers on the walls of pyramids." Geology as geo-graphics. Where is the Champollion to decipher this code?

FUZZY

THE LOGIC of place is fuzzy—not clear, not precise; or, perhaps, clear in its obscurity, precise in its imprecision. The principle of non-contradiction (either/or) does not hold because every place is contradictory, even self-contradictory. When opposites mingle without uniting, lines of separation cannot be drawn cleanly. If thinking *about* place is to be precise, it must be rigorously fuzzy.

COMPLIANCE

WHAT IF biology were geometric and geometry were organic? Angles would no longer be right, and figures would lose their edge; lines would twist, bend, curve, and turn but would not break. Forms would no longer be abstract, closed, and fixed but would morph in unexpected ways to create unimagined shapes. Order would not disappear but would be different; calculations would be recalibrated, measures changed. We would have to learn to yield, not force; respond, not react; comply, not compel.

TIME

TIME IS not one but many—times are layered on and folded into one another, overlapping without coming together: linear/cyclical, mechanical/organic, digital/analog, cosmic/earthly, prehistoric/historic, modern/postmodern, global/local, inhuman/human. Which time is real, and which is not?

Saint Augustine once confessed, "What then is time? I know what it is if no one asks me what it is; but if I want to explain it to someone who has asked me, I find that I do not know." The longer he mused, the more puzzled he became until he finally concluded,

It is incorrect to say that there are three times—past, present, and future. Though one might perhaps say: "There are three times—a present of things past, a present of things present, and a present of things future." For these three do exist in the mind, and I do not see them anywhere else: the present of things past is memory; the present of things present is sight; the present of things future is expectation.

No time without self, no self without time. Time and self seem to be inseparably joined in a loop that appears closed.

But not all time is human; there is a time out of mind, a time beyond time that is nonetheless in time. This strange temporality, which is never present but is not absent, is what makes every present and all presence possible. Always already past, it draws near as the future that never arrives, leaving the present eternally open. This time exceeds memory and, thus, cannot be recollected; it is remembered as forever forgotten. Time im(-)memorial is utterly inhuman, and yet humanity as well as everything else exists only in its wake.

COMPLACENCY

TO BE is to be on edge. Imbalance, not balance; disequilibrium, not equilibrium; disproportion, not proportion. Every point is a tipping point where pleasure and pain become indistinguishable. Tension creates vitality; restlessness keeps things moving. When tomorrow is yesterday, life is over. Com-place-ncy is death.

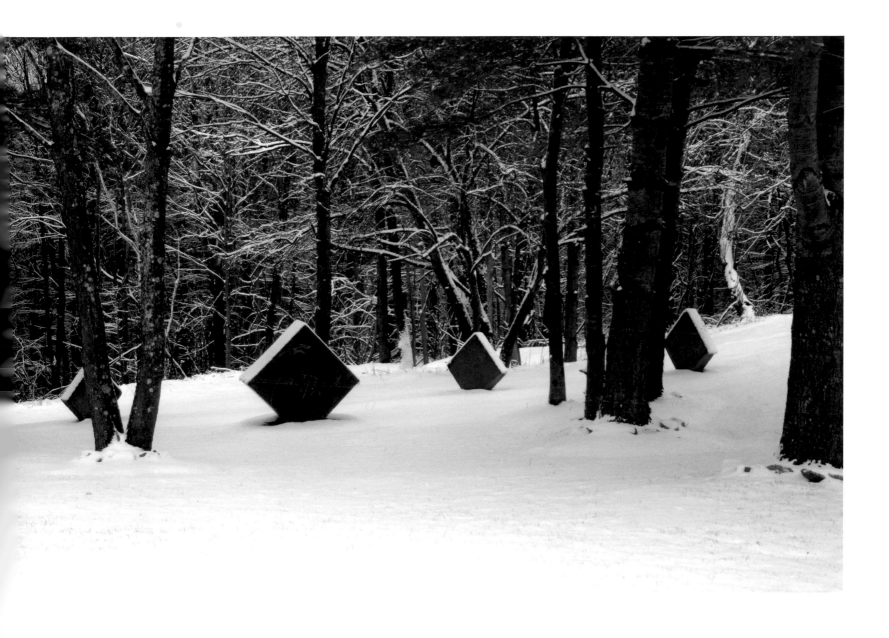

SNOW

THE COLOR of nothing, I suspect, is white. White like the whale:

> Is it that by its indefiniteness it shadows forth the heartless voids and immensities of the universe, and thus stabs us from behind, with the thought of annihilation, when beholding the white depths of the milky way? Or is it, that as in essence whiteness is not so much a color as the visible absence of color; is it for these reasons that there is such a dumb blankness, full of meaning, in a wide landscape of snows—a colorless, all-color of atheism from which we shrink?

But we not only shrink from the thought of annihilation; we are also strangely drawn to it.

Sometimes the snow falls so fast and the wind blows so hard on Stone Hill that everything disappears. The line separating up and down, left and right, inside and outside, heaven and earth vanishes in a swirling shroud. This shroud envelops and invades, until you are filled with an emptiness so vast that it cannot be contained. As the storm gathers force, snow and wind cover your tracks, leaving no path for return. If you are fortunate, panic gives way to calm, and the white noise of wind echoes the colorless all-color of atheism. This is the *via negativa*: losing yourself to find yourself.

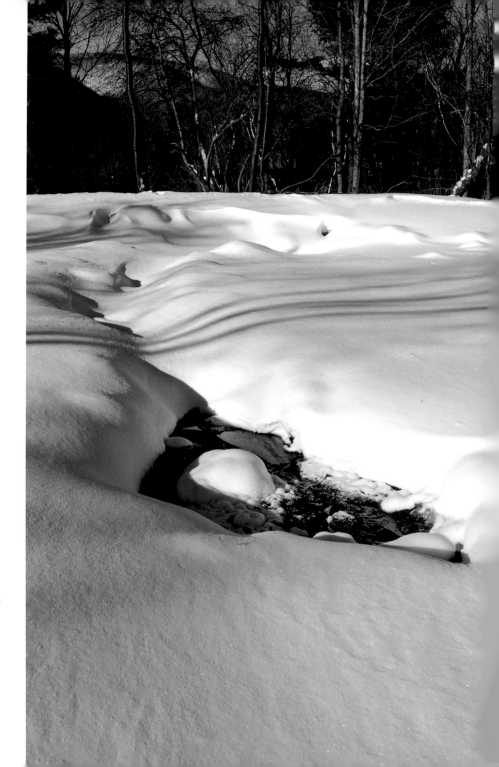

WINTER

WHEN WINTER comes unexpectedly early, it appears as sheer grace. Radar cannot see everything—predictions sometimes fail; surprise, astonishment, and wonder are still possible. Snow falling before the lawn's last mowing covers tall grass and bright autumn leaves, bending branches to the breaking point until they snap and release what sounds like gunshots that echo through the woods. Apples and pears not yet fallen are capped with snow and look like ice cream cones awaiting giddy children. The suddenness with which fall's rustle gives way to winter's stillness is jarring. Something is ending, and something is beginning. Snow blanketing the ground mutes sounds, and once again we hear the snowman's silence.

SPRING

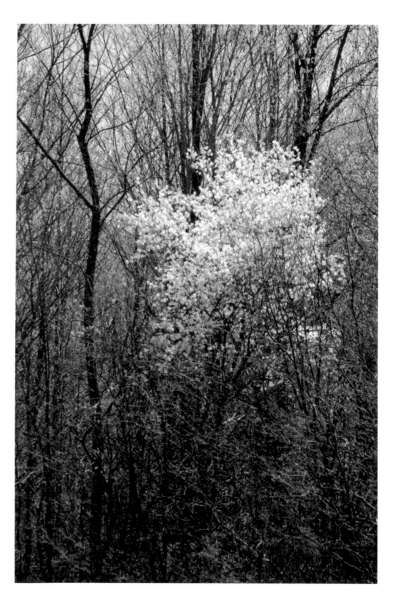

CHANGE. As always, it's a matter of light or its absence. Morning and evening light change so gradually that we do not notice it, until one day we realize that spring is near. Its approach breeds impatience—spring delayed is desire deferred. Often I hear spring before I see it. Red-winged blackbirds return and perch on last year's cat-o'-nine-tails in the upper pond, calling to mates they cannot see. The surest sign of spring, however, is the sound of peepers. When days grow warm, a single chirp quickly grows to a melodious chorus that fills the emptiness of night. My mother taught me to attend to this sound at her home in Pennsylvania, and I have tried to pass on her lesson to my children and grandchildren.

Fat loses its savor without lean. The light of spring is brighter because of winter's darkness; its songs fresher because of winter's silence; its colors brighter because of winter's austerity. I could not live in a place where the seasons do not change. Spring is a promise in a world where hope is fragile.

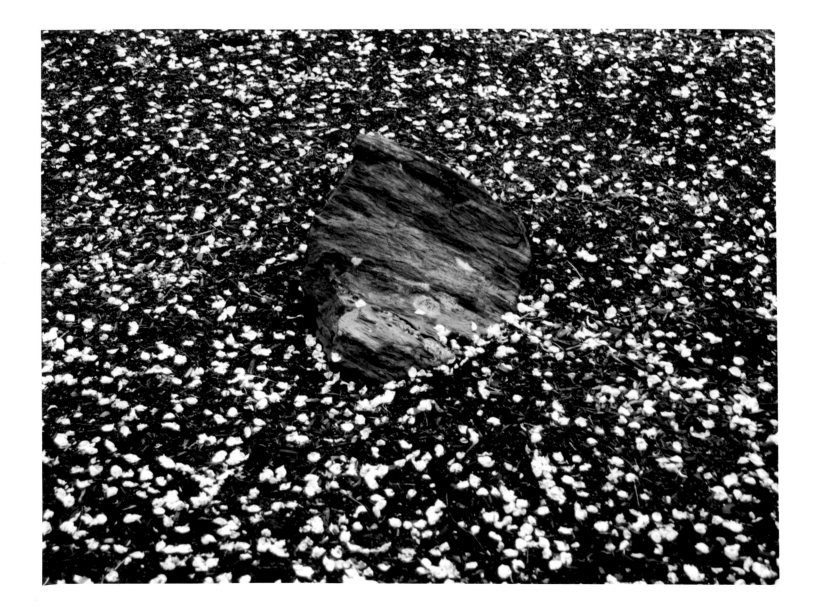

SUMMER

IN LATE afternoon, the heat steadily rises, and high billowy clouds drift over the mountains from the west. As night falls, distant thunder begins to rumble softly, and the horizon flashes intermittently like strobe lights at a disco party. Around midnight, the storm arrives. Thunder explodes, bouncing off the hills and rattling the windows; bolts of lightning dart across the sky, and the whole valley—cast in a strange light that is neither heavenly nor earthly—flares before our eyes. Like crooked arrows seeking their target, heavenly fire takes aim at the eye of the pit sunk deep into the earth. Even if the storm has been forecast, the moment of illumination is unpredictable. Those who venture into this night expose themselves to forces no human can master:

> He said to the disciples, "The time will come when you will long to see one of the days of the Son of Man, but you will not see it. They will say to you, 'Look! There!' and 'Look! Here!' Do not go running off in pursuit. For like the lightning-flash that lights up the earth from end to end, will the Son of Man be when his day comes."

In the depth of this night, heaven and earth become one, at least for an instant. Then the thunder fades, and the flickering light dims; finally, the rain begins to fall, and parched earth becomes moist again.

FALL

FALL ON Stone Hill is unlike the season anyplace else. It begins when a monarch butterfly gently settles on a milkweed pod, gathering nourishment for its long trip south. While Canada geese fly low, honking at dawn and dusk, squirrels and chipmunks gather nuts and seeds and noisily hide them in the walls of the barn. Deer return from summer vacation until hunters drive them back to the mountains. Coyotes leave their lairs to stalk unsuspecting flocks of turkeys. Days shorten, nights grow colder, and stars draw closer until you can almost reach out and touch them. Kant was right about the starry heavens, even if he was wrong about the moral law.

But it is the light that makes the place and the season so special. When the sun drifts south, its angle shifts and colors change. Yellows and reds, oranges and browns, ambers and umbers both absorb and reflect the changing light to create a glow that becomes so absorbing that it is impossible not to lose yourself in it. As the old self you thought you knew slips away, something unexpected happens—suddenly you no longer merely see light but hear it as a tangible presence pressing on your eardrums, creating a resonance that lingers long after night falls and winter arrives.

EXCESS

NATURE'S EXCESS is terrifying. It is too much, always too much. Too many seeds to produce a tree, too many worms to work the earth, too many tadpoles to create a frog, too many sperm to fertilize an egg, too many people born to die. Fecundity, profusion, and abundance pushed to the point of absurdity. This wasteful economy renders life so cheap that redemption seems all but impossible.

INDIFFERENCE

THE WRINKLED surface of rock long buried beneath the earth is the anonymous face of indifference. My life does not matter to this rock of ages. It was there long before my birth and will be there long after my death. The indifference of rock puts us in our place by disclosing a place that can never be our own. Although dreadful, this indifference may be the only remaining comfort in a world the gods long ago deserted. There is, after all, freedom in accepting that we will be forgotten.

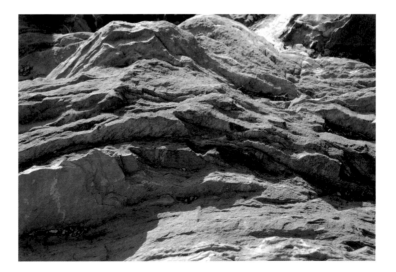

INHUMAN

THE COUNTENANCE of stone is the guise of the inhuman. It is not so much the anonymity as the indifference that is haunting. Creases and crevices are wrinkles in a face that stares at us but sees nothing. Tiny fossils of life from ancient depths are mere blemishes that rain and wind gradually wipe away. This past is our future. Every rock is a gravestone awaiting an inscription that will be erased.

ABANDONMENT

BEFORE THE beginning, there is abandonment. I am, we are, abandoned, not once but again and again and again. Being comes to pass as abandonment—to be is to have been abandoned. Nothing abandons, yet there is abandonment; abandonment occurs as having taken place without ever taking (a) place. Always already past, abandonment remains shrouded in oblivion. I can no more remember the primal event that allows me to be than I can anticipate the ultimate event that allows me not to be.

Since abandonment happens before the beginning, I am forever after—after the past that was never present but eternally returns as the future that never arrives. I am, therefore, simultaneously before and after. I am abandoned *to* time, which is always abandoning me. I never have time; rather, time has me. Although profoundly disturbing, the abandonment *to* time, the abandonment *of* time, creates the infinite restlessness that keeps everything in motion.

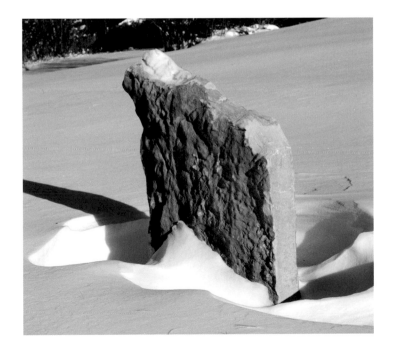

CULTIVATION

THERE IS no culture without cultivation. Thinking is an art that remains grounded in earth, even when it tries to escape its material conditions. The more cultured the person, the farther he tries to distance himself from humble beginnings. When local dialect gives way to cosmopolitan speech, it is impossible to know where anyone comes from. The more refined the person, the more rarefied her airs, until she eventually loses touch and forgets who she is. In cultured society, words all too often are pretentious, and language is a web woven to deceive. To unravel this tis-sue of deceit, thinking must return to its cultic roots. The matter of thought is not immaterial but remains the very stuff of reflection. If thoughts are not dirty and words are not soiled, they are not real. The truly cultured person never trusts an artist or a writer who does not have dirt under her fingernails.

PRACTICE

THERE IS much that can be known only
through practice. Practice cultivates an
awareness that eludes words but shapes
thought. Thinking has a rhythm of its
own that can be courted but not coerced.
Practice is where physical work and mental
play meet. Repetition attunes body and
mind to alternative registers that can be
communicated only indirectly. Practice
always requires a specific place—there is
a place for practice and a practice of place.
We do not know a place until it becomes
part of our practice.

RAKING

RAKING IS a ritual that attunes us to the earth's patterns and rhythms. It is best done alone and in silence. As the to-and-fro of the rake follows the lay of the land, the mind slips into a meditative state in which motion becomes rest. In this moment, it is no longer clear where body ends and earth begins.

WALKING

WE HAVE forgotten how to walk and, thus, no longer know how to think. Some of the most arresting modern philosophers have thought most perceptively on their feet—Kierkegaard, Kant, Rousseau, Benjamin, Heidegger, Serres. Walking paces thought by setting the body in motion and giving the mind enough time to stray, wander, err. "Saunter," after all, derives from *santeren*, which means "to muse." We cannot know a place until we walk it. The best time to walk on Stone Hill is late afternoon when the sun is setting. Not just any walking will do—the walking that matters most has no purpose; it is not done for the sake of exercise or travel, nor is it undertaken as a pilgrimage to a distant land. Walking is movement in place that lets the mind ramble. Aleatory connections emerge and dissolve in pauses and gaps, creating lines that can never be retraced. The person who truly knows how to walk realizes that he passes this way only once. Neither straight nor direct, paths for walking lead nowhere. This no-where is not elsewhere but is now-here, and in this elusive moment nothing is more important than the pedestrian.

STONES

"HANDLING STONE," the poet Gary Snyder once told Jack Kerouac, "is a way to pay attention to the earth." For those attentive to what is usually overlooked, a mysticism of matter is revealed in stone: "The closer you get to real matter, rock, air, fire, wood, the more spiritual the world is." *Tat tvam asi*. Minerals circulate through our bodies, and our bodies eventually nourish the earth that nourishes us. Individual stones seem solid but when artfully assembled, flow freely. As with so many things, the beauty of stone is in the details. Subtle colors, imaginative shapes, curious cracks, and puzzling fissures. This beauty exceeds Euclid's grid and eludes every calculation designed to capture it. Stones teach us that everything solid has its faults and that the ground beneath us is not secure but suffers tectonic shifts that change everything. The beauty of stones is more troubling than reassuring because it is utterly gratuitous and completely spontaneous. No mind conceived these designs; no hand carved these figures. Beauty etched in stone represents nothing and is without meaning. This is what makes it sublime.

GRANITE

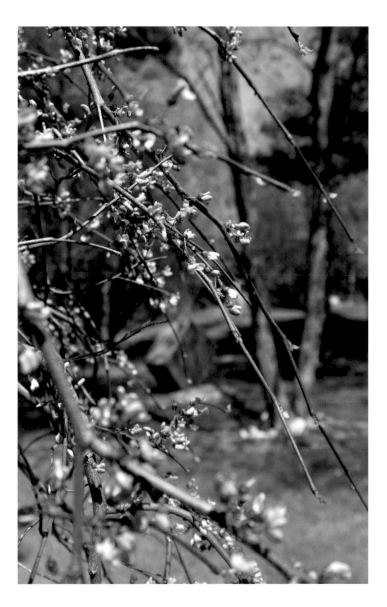

WHAT IF God is found in earth rather than heaven? Perhaps even on or in rock:

> Moses said to God, "Please show me your glory." And the Lord said, "Behold, there is a place by me where you shall stand on the rock, and while my glory passes by I will put you in a cleft of the rock, and I will cover you with my hand until I have passed by. Then I will take away my hand and you shall see my back, but my face shall not be seen."

Rock. Rock of Ages. Hard enough to stand the test of time, a lasting memorial to those who have passed away. But even the hardest rock eventually erodes—words are erased, memories fade, and monuments designed to remember become memorials to forgetting. Perhaps such forgetting is a way to remember that nothing lasts. Rock, like everything else, returns to earth. Might the earth's interior be the hidden face of God?

MARBLE

THE SURFACING whale turns out to be marble. The dusty beige skin is chipped to reveal ancient whiteness. Not just any stone but Stockbridge Marble thrust westward from ocean depths off the coast of Nantucket, where Ishmael, Ahab, and Starbuck once lived. Nearby Stockbridge, where Thoreau visited and Wharton, Melville, and Hawthorne lived and wrote. Did they collect fragments of this stone as they climbed Mount Greylock? Did Melville first see the whiteness of the whale in the face of this marble? Is this the marble that Hawthorne's Ethan Brand burned in his lime kiln on the other side of Stone Hill, while conversing with Satan about his "Unpardonable Sin"? What terrible secrets does this marble harbor?

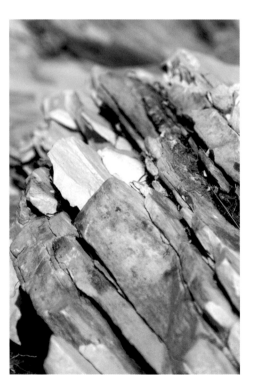

MORAINES

NOT ALL streams and rivers flow with fresh-water from falling rain, hidden springs, or melting snow. Some are dry rivers of stone filled with debris gathered from glaciers, mountainsides, and valley floors. Although seemingly static, they flow imperceptibly, slowly eroding hard edges and carrying even the heaviest boulders with them. Moraines are where the striated and the smooth are woven together to create moiré patterns vibrating with intensity. To the patient eye, this tapestry never remains the same.

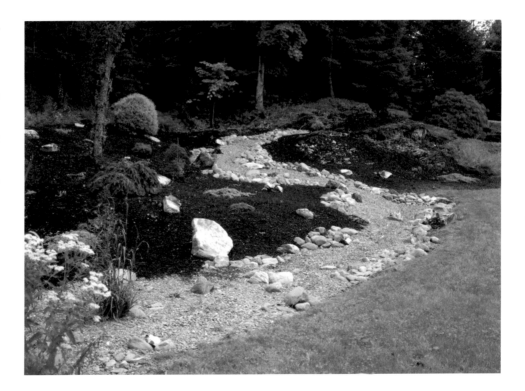

ELEMENTAL

WE LONG for the elemental more than the elements. The elemental is the beginning and the end figured and refigured by earth, air, fire, and water. A primal, even archaic, source that is always receding, the elemental is the vanishing ground of whatever is and whatever is not. Sending every present, it is always on the way, yet never arrives. That is why we are forever after it—always in its wake, ever in its pursuit. The elemental is not the sub-stance of the world because it lies between rather than beneath. Neither event nor stuff, the elemental is the nexus that binds and rebinds the elements without which life is impossible. Approaching the edge of the elemental sharpens the senses and clears the mind.

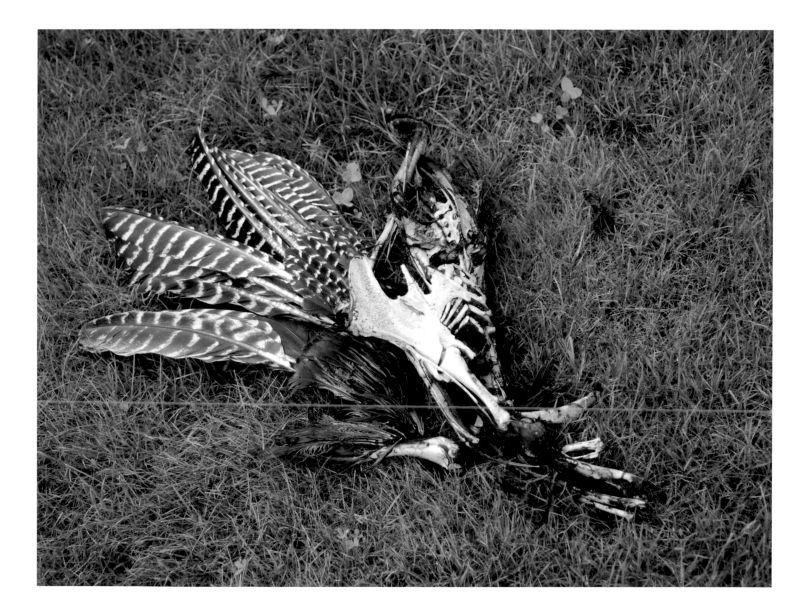

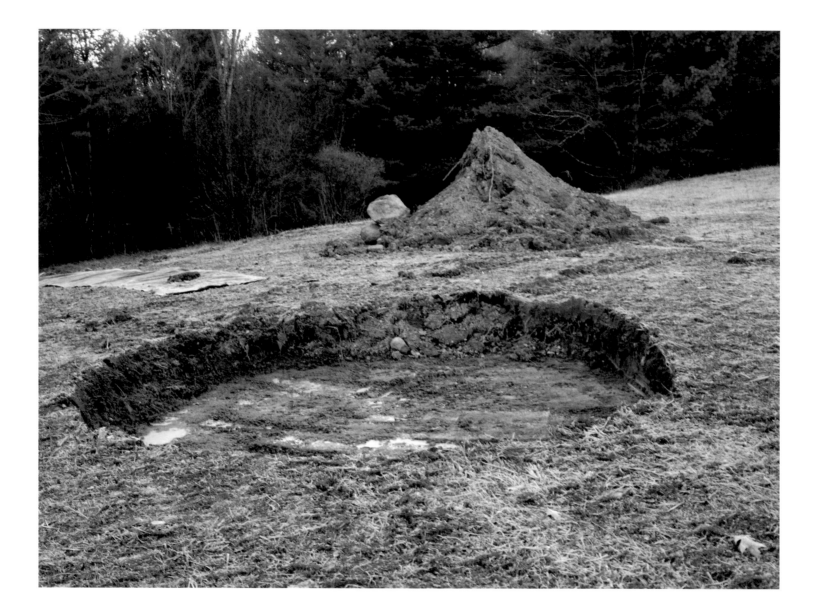

EARTH

I implore you, my brothers, remain faithful to the earth and do not believe those who speak to you of unearthly hopes! They are poisoners whether they know it or not.

Despisers of life, they are the dying ones. The earth is weary of them; let them fade away!

THE LONGER I dwell on Stone Hill, the more I realize that earth is a place that is a condition. It is the abyssal ground through which (the) all everlastingly flows. Nothing is stable, nothing static; everything is hollow at its core. Earth is alive—it gives and takes and gives again, living through us even as we live through it. Like an ancient alchemist laboring in underground furnaces, earth transforms humus into humans, who, in turn, become humus for others. If hope is unearthly, it is unreal. To be of earth is to be mortal, and to remain faithful to earth is to accept mortality humbly. With Nietzsche, "I want to become earth again, so that I may have peace in the one who bore me." This is the only faith that matters.

AIR

"THE MEASURE of a garden is the air that clings to it." The magic of a garden makes the invisible visible without dispelling its mystery. "An ocean of air, miles deep, slides, swirls, and curls around the skin of the planet. Garden atmosphere is a bubble of refinement in the sea of air that washes over us. It is a permeable capsule clarified by the absorption and reflection of the garden colors, textures, and aromas." To see these colors, feel these textures, and smell these aromas, we must let the garden circulate through us.

WIND

HOW DO you capture wind? It cannot be photographed; video shows its effects but not wind itself. Try to record it, but, when played back, the sound is never right. In fall, it whistles; in winter, it howls; in, spring, it stirs; in summer, it rustles. Sometimes wind's bursts are short; other times it howls relentlessly for days and nights. Wind defies gravity by increasing speed as it rises; it wears away the hardest rock and fells the strongest trees. Some days when it hits the house, it explodes like a rogue wave crashing on a rock-strewn strand. One Memorial Day, a tornado rushed up the valley and skipped across Stone Hill, knocking down trees in the woods and along the driveway. When I saw the devastation, I decided to cut down all the trees that might fall on the house and barn. But without the trees, we are more exposed than ever because nothing remains to break the force of wind. How can something intangible and invisible be so strong? It is not surprising that people have long believed that wind is spirit and that spirit appears without appearing as wind.

FIRE

ON THE shortest and longest nights of the year, axes are aligned, the perfectly symmetrical pit is prepared, and wood is collected. As the sun slips behind the mountain, family and friends gather, a match is struck, and a fire is ignited. Gods and spirits ancient and modern join those gathered around the flames to reenact a ritual as ancient as humanity itself. In this fire, the terror of the universe has not yet fossilized, and heat generates passion that is never satisfied. Creation and destruction, Eros and Thanatos, life and death, altar and pyre, purification and pollution, heaven and hell, spirit and flesh, sacred and profane meet in fire. Glowing ash drifting heavenward meets ancient light from distant stars, only to fall back to earth, where it smolders for half the year. The world is ablaze.

WATER

MEDITATION AND WATER are forever wed. Water is older than creation and, perhaps, more ancient than God. Always there, yet having no place of its own, water is the *fons et origio* of life itself. There is no life without water; indeed, life itself is a fluid medium. That is why ancient philosophers regarded water as the creative essence of everything.

But that is not the whole story; water destroys as well as nourishes. Ancient myths represent water as the monstrous source of chaos that must be monitored and mastered. Marduk creates by slaying the water monster Tiamat, and God's word dams primordial waters. But the victory is never complete, and the contest always ends in a draw. The serpent survives to disrupt the garden, setting earthly life in motion ever again. Monster becomes serpent becomes whale. Life in death, death in life: water's disruption regenerates even when it turns violent.

RAIN

IN LATE JULY, the grass turns brown and brittle, and the earth cracks like peeling paint on a plaster wall. Day after day, the sun beats down until ponds dry up and wells run dry. Some nights bring thunder and lightning but never any rain. Plants shrivel, and many die; leaves fall from trees far too early. Dust from the parched streambed swirls in clouds that offer no relief. In the West, wildfires burn for months, each year worse than the last. Summer turns to fall, fall to winter, and winter to spring—and still rain does not come.

ICE

ICE IS a lens that exposes the fuzzy by magnifying flows. When we glimpse the world through ice, things are distorted in ways that refocus attention. Depths appear deeper and darker; mountains fade to sky and sky to mountains until the two seem to be one. The enigmatic color along the erased horizon is neither earthly nor heavenly but something far more mysterious. A winter stream rushing over rocks beneath ice comes alive with morphing forms that seem to be living. Looking at rather than through ice, we discover intricate designs that no human hand could have drawn. Surfaces become unfathomable in their delicate complexity. What makes the enigmatic beauty of this art so touching is the melancholy awareness of how briefly it lasts.

WOOD

FORM AND MATTER—*morphe* and *hyle*. Trees and roots, etymological and genealogical as well as biological. Aristotle named the primordial soup from which the world was formed *hyle*, which in Greek originally meant "forest" rather than "matter." For reasons that remain obscure, the Romans translated Aristotle's *hyle* as *materia* instead of *silva*, thereby setting off endless chains of association. *Materia* derives from the same root as *mater*, which means "mother." *Hyle . . . silva . . . materia . . . mater.* Wood becomes matter, which, like a blank page, awaits inscription.

This story is as ancient as it is modern. In Canaanite myths and iconography, the stone that carves is male and the wood that receives the inscription is female. In Israel, after a theophany, the patriarchs were ordered to erect stone—never wooden—pillars. Eventually, a standing stone and a wooden pole became defining features of the sanctuary. Although the pole was not associated with the goddess, vestiges of her remained. The word for the pole is the common noun *ashera*, which is the name of the mother goddess, who is the consort of El. Stone and wood, El and Ashera, pen and paper, hoe and earth join in the act of creation.

FOREST

ON STONE HILL, the forest is not primeval. Growth is always second growth, third growth, fourth growth . . . : "a piece of land worked on, lived on, grown over, plowed under, and stitched again and again, with fingers or with leaves, in and out and into human life's thin weave." Trails that the Mohawk cut on Stone Hill while making their way to the Hudson River have long since disappeared. The remains of the fort that once guarded the western frontier of the territory cannot be found. But traces of pastures where sheep grazed less than a century ago can still be uncovered if you allow time to look. Deep in the woods, the patient eye sometimes notices a slight ridge in the earth that looks straighter than it should be. Sweep away the leaves, brush away the dirt, and the ruins of a stone wall that once marked the boundary of a farmer's field are revealed. Sometimes we discover our future in the past. How many years will it take the forest to reclaim the fields that I have cleared?

FLOWS

PERHAPS WHILE hiking up Mount Greylock, Thoreau paused to write,

All things seemed with us to flow; the shore itself, and the distant cliffs, were dissolved by the undiluted air. The hardest material seemed to obey the same law with the most fluid, and so indeed in the long run it does. Trees were but rivers of sap and woody fiber, flowing from the atmosphere, and emptying into the earth by their trunks, as roots flowed upward to the surface. And in the heavens there were rivers of stars, and milky-ways, already beginning to gleam and ripple over our heads. There were rivers of rock on the surface of earth, and rivers of ore in its bowels, and our thoughts flowed and circulated, and this portion of time was the current hour.

Rivers in the heavens marking stars long gone. Streams of stone bearing mineral memories of telluric time long lost. Nothing is stationary; everything flows into everything else. Mountains are no more fixed than rivers; earth is no more stable than sky. It takes a trained eye to detect movement where there is no motion, but once we see it everything shifts. What appeared still becomes no more than a momentary eddy in circulating flows that rush upstream.

WASTE

MUCH OF what matters most in life is considered (a) waste—a waste of time, a waste of effort, a waste of money. Like spending years composing a symphony that no one ever hears, spending a life writing a book that no one ever reads, or spending thousands of dollars creating gardens and sculptures that no one ever sees. Senseless.

But what if values shift between noon and the evening of life? Perhaps the prudent calculation of life's noon is the real waste of time, and the expense of pursuing the incalculable as evening draws near is all that makes sense in a world at the edge of madness.

PYRAMID

THE PYRAMID—so complex in its simplicity. From prehistory to the New Age, the pyramid has been the locus of power. Its form is pure, even primal; its matter is stone, sometimes metal. Mathematics, some maintain, was born in the shadow of the pyramid. What is this shadow? Where is this shadow?

A place where opposites meet: light and darkness, death and life, tomb and altar.

Pyramid: Latin, *pyramis, pyra*
Greek, *puramis, pura*—funeral pyre

Some have a point; others do not. Some are labyrinthine tombs whose sealed crypts render everything cryptic. Others are altars of sacrifice where meaning is consumed in a pointless economy. The underbelly of capital (from *caput*, head) is a pyramid with its tip knocked off. How many more must be sacrificed on the altar of this god?

PIT

EARTH AND SKY meet in the eye of the pit whose axes are celestial as well as terrestrial. The χ of the pit locates place by measuring time and marks time by tracing the place of shadows. A circle within a circle, this eye is open to both heaven and hell. This is the margin along which life is lived. Not merely an object among objects, the pit refigures Wallace Stevens's "poem within a poem," which, like a jar placed on a Tennessee hill, "assembles a world":

> The wilderness rose up to it,
> And sprawled around, no longer wild.
> The jar was round upon the ground
> And tall and of a port in air.
>
> It took dominion every where.
> The jar was gray and bare.
> It did not give of bird or bush,
> Like nothing else in Tennessee

Gathering and assembling, binding and rebinding. The pit is place, where world is simultaneously created and turns to ash.

SIGN

THERE IS a pit in the midst of the pyramid—
a place that remains open even when it
is sealed. A closed opening and an open
closure is the sign of the sign that is the
grave. If we are patient enough to listen,
words tell stories. The Greek word *sema*
means both "sign" and "grave." Sign as
grave—grave as sign. The death or the
rebirth of meaning? Is the grave empty
or full? If the stone cannot be rolled back
and the seal broken, all remains uncertain.

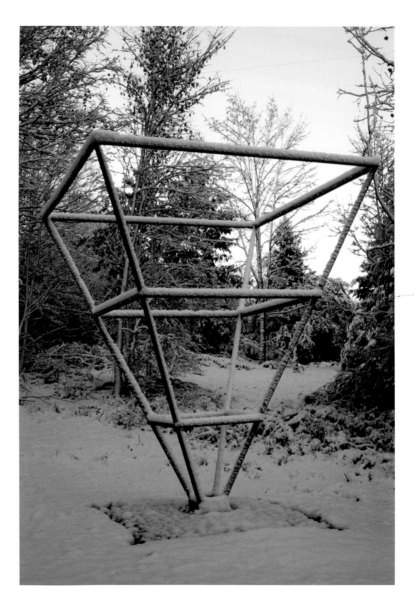

SACRIFICE

THE FIRST snow of the season covered rocks and stream, creating an image reminiscent of an impressionist canvas. As dusk began to fall, the huge owl that hoots loudly on moonlit winter nights swooped down and settled on the snow. After a few minutes, the owl began a strange hopping movement, and a red squirrel dangling from his claws appeared. For more than half an hour, the owl struggled to drag the dead body across the snow-covered rock garden and eventually disappeared into the nearby woods. The next morning, the owl's tracks and a thin trail of the squirrel's blood were still visible in the snow. The squirrel no longer scrambles noisily through the barn walls searching for food hidden last fall, and it is once again quiet enough for writing.

BURIAL

WE DO not know who we are until we know the place where we will be buried. For the first time in history, most people have no idea where they will be buried or where their ashes will be scattered, and, thus, they do not know who they are. The place-lessness of the dead is a symptom of the nomadism of contemporary life. To regain our bearings, it is necessary to mark the place of our own burial. Not "Here I stand" but "Here I will lie."

BONES

BONES ARE what remain—what remain of the remains. Even when bodies are consumed in sacrificial fires or funeral pyres, bones or their fragments are left over. Bones embody a disturbing coincidence of the personal and the impersonal. Nothing is closer to us than our bones. Indeed, bones are the substance of our very being; for those who know how to read them, bones tell the stories of the lives they once supported. And yet, for all their individuality and idiosyncrasy, there is something terrifyingly inhuman about bones. They allow silence to speak through their anonymity. Instead of recalling the life they once bore, bones memorialize oblivion. It is not the mere cessation of life but its forgetting that renders death final. The bones of others prefigure the unavoidable nothingness awaiting all of us. The dread of nothing does not diminish the beauty of bones but renders it all the more poignant. Like intricate designs etched on canyon walls by centuries of wind, rain, ice, and sand, bones reveal a beauty far more vast than any conceived by human invention.

RELICS

My necklace and ornaments are of human bones; I dwell among the ashes of the dead and eat my food in human skulls. . . . We drink liquor out of the skulls of Brahmans; our sacred fires are fed with the brains and lungs of men mixed up with their flesh, and human victims covered with the fresh blood gushing from the dreadful wound in their throats, are the offerings by which we appease the terrible god [Maha Bhairava].

IDLENESS

"TO DO nothing," Oscar Wilde avers, "is the most difficult thing in the whole world, the most difficult and the most intellectual." Doing nothing is essential for thinking to occur. Many of the most important thoughts are unintentional—they can be neither solicited nor cajoled but have a rhythm of their own, creeping up, arriving, and leaving when we least expect them. It is important to cultivate the lassitude of mind that clears a place for the arrival of what cannot be anticipated. Idleness allows time for the mind to wander to places never before imagined and to return transformed.

DWELLING

PLACE IS where we dwell. Dwelling is a lingering and tarrying that errs and wanders, all the while staying in place. Those who dwell travel far without moving. No place is too small, no time too brief for dwelling. Dwelling requires the patience to forget tomorrow for today and the willingness to follow paths that lead nowhere.

CONTENTMENT

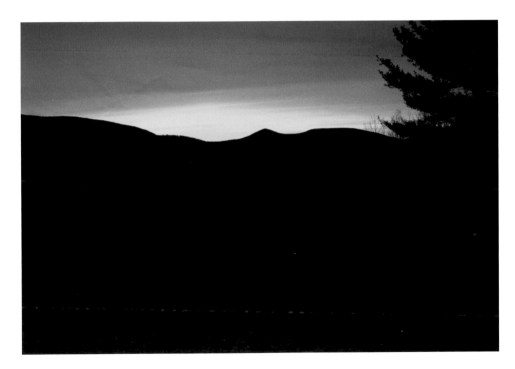

WHAT IF we became discontent with discontent—gave up longing for what is not and accepted what is? Perhaps it would then be possible to "arrive where we started / And know the place for the first time." Only then might we understand Zarathustra's lasting lesson: "Happiness should smell of earth and not contempt for the earth."

NOTES

Introduction: Starbucks, "Our Heritage," http://www.starbucks.com/about-us/our-heritage, and "Online Community," http://www.starbucks.com/coffeehouse/community; Karl Marx and Friedrich Engels, *The Communist Manifesto*, in *The Marx-Engels Reader*, ed. Robert C. Tucker (New York: Norton, 1978), sec. 1, para. 18, l. 12.

Displacement: Michel Serres, *The Five Senses: A Philosophy of Mingled Bodies*, trans. Margaret Sankey and Peter Cowley (New York: Continuum, 2009), 257.

Posthuman: Ray Kurzweil and Terry Grossman, *Fantastic Voyage: Live Long Enough to Live Forever* (New York: Penguin/Plume, 2005), 3, 14.

Nihilism: Friedrich Nietzsche, *The Will to Power*, trans. Walter Kaufmann (New York: Random House, 1967), 3.

Project: Martin Heidegger, *Poetry, Language, Thought*, trans. Albert Hofstadter (New York: Harper & Row, 1971), 53; Dan Snow, *Listening to Stone* (New York: Artisan, 2008), 17.

Philosophy: Henry David Thoreau, "Walking," Transcendentalists, www.transcendentalists.com/walking.htm.

χ: Maurice Merleau-Ponty, *The Visible and the Invisible: Followed by Working Notes*, ed. Claude Lefort, trans. Alfonso Lingis (Evanston, Ill.: Northwestern University Press, 1968), 137, 143, 147.

God: Friedrich Nietzsche, *The Gay Science*, trans. Walter Kaufmann (New York: Random House, 1974), 181.

Art: Wallace Stevens, "An Ordinary Evening in New Haven," in *The Collected Poems of Wallace Stevens* (New York: Knopf, 1981), 472; Nietzsche, *Will to Power*, 12.

Night: Stevens, "The Snow Man," in *Collected Poems of Wallace Stevens*, 9.

Gardens: Rebecca Solnit, *Wanderlust: A History of Walking* (New York: Viking, 2000), 74.

Abstraction: Edward S. Casey, *Getting Back into Place: Toward a Renewed Understanding of the Place-World* (Bloomington: Indiana University Press, 1993), 226.

Parasite: Matthew 26:26.

Human: Robert Pogue Harrison, *The Dominion of the Dead* (Chicago: University of Chicago Press, 2003), 34; Søren Kierkegaard, *Philosophical Fragments*, trans. Howard Hong and Edna Hong (Princeton, N.J.: Princeton University Press, 1985), 8; Heidegger, *Poetry, Language, Thought*, 96.

Grace: Dan Snow, *In the Company of Stone: The Art of the Stone Wall: Wall and Words* (New York: Artisan, 2001), 6.

Bliss: Roland Barthes, *Roland Barthes*, trans. Richard Howard (New York: Hill and Wang, 1977), 112.

Wildflowers: Angelus Silesius, "Without Why," in *The Cherubinic Wanderer*, quoted in Martin Heidegger, *The Principle of Reason*, trans. Reginald Lilly (Bloomington: Indiana University Press, 1997), 37.

Holes: Kevin Hart, "The Real World," in *Flame Tree: Selected Poems* (Tarset: Bloodaxe Books, 2002), 68.

Revelation: Herman Melville, *Moby-Dick, or The Whale* (Berkeley: University of California Press, 1979), 315.

Time: Augustine, *The Confessions of St. Augustine,* trans. Rex Warner (New York: New American Library, 1963), 267, 273.

Snow: Melville, *Moby-Dick,* 197–198.

Summer: Luke 17:22–24.

Stones: Gary Snyder to Jack Kerouac, quoted in Solnit, *Wanderlust,* 146; Snow, *Listening to Stone,* 31.

Granite: Exodus 33:18–23.

River Stone: Kevin Hart, "River Stone," in *Morning Knowledge* (Notre Dame, Ind.: University of Notre Dame Press, 2011), 30.

Walling: Snow, *Listening to Stone,* xii.

Earth: Friedrich Nietzsche, *Thus Spoke Zarathustra,* trans. Marianne Cowan (Chicago: Regnery, 1957), 4 [translation modified], and *Thus Spoke Zarathustra: A Book for All and None,* ed. Adrian Del Caro and Robert Pippin, trans. Adrian Del Caro (New York: Cambridge University Press, 2006), 55.

Air: Snow, *Listening to Stone,* 120.

Forest: Annie Dillard, *Teaching a Stone to Talk: Expeditions and Encounters* (New York: Harper & Row, 1982), 131.

Flows: Henry David Thoreau, "Thursday," in *A Week on the Concord and Merrimack Rivers; Walden, or, Life in the Woods; The Maine Woods; Cape Cod* (New York: Literary Classics of the United States, 1985), 269–270.

Pit: Stevens, "Anecdote of the Jar," in *Collected Poems of Wallace Stevens,* 76.

Relics: Khrishna Mishra, *Prabodha Chandrodaya* (*Rising of the Moon of Awakened Intellect*), an allegorical drama performed in 1065 C.E., quoted in Mircea Eliade, *Yoga: Immortality and Freedom,* trans. Willard R. Trask (New York: Pantheon Books, 1958), 298.

Prayer: Hart, "The Stone's Prayer," in *Flame Tree,* 23.

Idleness: Oscar Wilde, "The Critic as Artist," in *Plays, Prose Writings, and Poems* (London: Dent, 1955), 275.

Contentment: T. S. Eliot, "Little Gidding," part V, in *Four Quartets* (New York: Harcourt, Brace, 1943), Allspirit: Spiritual Poetry, Quotations, Song Lyrics, and Texts, http://allspirit.co.uk/gidding.html; Nietzsche, *Thus Spoke Zarathustra,* ed. Del Caro and Pippin, 91.

ACKNOWLEDGMENTS

Recovering Place: Reflections on Stone Hill is the most multifaceted and complex work I have undertaken and would not have been possible without the interest and support of many people. I would like to express my deep gratitude to James Jordan and Wendy Lochner for their enthusiastic support; Lisa Hamm for her exceptional design work; Herbert Allen for his long-standing interest in, and generous support of my work; Michael Conforti and his colleagues for their generous support and for all they do at the Clark Art Institute to make Stone Hill a special place; Brian Turton, Valerie Ross, and their remarkable crew of artists and artisans (Bryan Anderson, Mike Banister, Ken Bink, Shannon Burns, Joshua Godell, Frank James, Mike Koczella, Billy Piantoni, Brian Reed, Jill Rickert, and Curt Vonschiling) for making visions a reality; Chelsea Ebin and Melissa Van for their help with countless details; Sharron Macklin for making sure the axes are aligned properly; James Allison for helpful tips about photography; Joe Thompson for unforgettable plane rides; Paul Karrabinos and Bud Wobus for geology lessons; Hank Art for botany lessons; Bob McCarthy for wildlife lessons; Cody and Connor Johnson for organizing and tweaking countless files; David Furlow for translating the real into the virtual; Margaret Weyers for always finding what I cannot; Jack Miles, Tom Carlson, and Sophie Black for their characteristically thoughtful responses; and, finally, my family—Dinny, Kirsten, Jonathan, Aaron, Frida, Selma, and Elsa—for patiently tolerating my crazy obsessions.

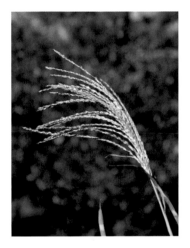

ALSO BY MARK C. TAYLOR

Rewiring the Real: In Conversation with William Gaddis,
 Richard Powers, Mark Danielewski, and Don DeLillo

Refiguring the Spiritual: Beuys, Barney, Turrell,
 Goldsworthy

Crisis on Campus: A Bold Plan for Reforming Our Colleges
 and Universities

Field Notes from Elsewhere: Reflections on Dying
 and Living

After God

Mystic Bones

Confidence Games: Money and Markets in a World
 Without Redemption

 Grave Matters (with Dietrich Christian Lammerts)

The Moment of Complexity: Emerging Network Culture

About Religion: Economies of Faith in Virtual Culture

The Picture in Question: Mark Tansey and the Ends
 of Representation

Critical Terms for Religious Studies

Hiding

The Réal: Las Vegas, Nevada (with José Márquez)

Imagologies: Media Philosophy (with Esa Saarinen)

Nots

Disfiguring: Art, Architecture, Religion

Double Negative

Tears

Altarity

Deconstruction in Context: Literature and Philosophy

Erring: A Postmodern A/Theology

Deconstructing Theology

Journeys to Selfhood: Hegel and Kierkegaard

Unfinished: Essays in Honor of Ray L. Hart

Religion and the Human Image (with Carl Raschke
 and James Kirk)

Kierkegaard's Pseudonymous Authorship: A Study of
 Time and the Self

RELIGION, CULTURE, AND PUBLIC LIFE

SERIES EDITORS: ALFRED STEPAN AND MARK C. TAYLOR

The resurgence of religion calls for careful analysis and constructive criticism of new forms of intolerance, as well as new approaches to tolerance, respect, mutual understanding, and accommodation. In order to promote serious scholarship and informed debate, the Institute for Religion, Culture, and Public Life and Columbia University Press are sponsoring a book series devoted to the investigation of the role of religion in society and culture today. This series includes works by scholars in religious studies, political science, history, cultural anthropology, economics, social psychology, and other allied fields whose work sustains multidisciplinary and comparative as well as transnational analyses of historical and contemporary issues. The series focuses on issues related to questions of difference, identity, and practice within local, national, and international contexts. Special attention is paid to the ways in which religious traditions encourage conflict, violence, and intolerance and also support human rights, ecumenical values, and mutual understanding. By mediating alternative methodologies and different religious, social, and cultural traditions, books published in this series will open channels of communication that facilitate critical analysis.

After Pluralism: Reimagining Religious Engagement,
 edited by Courtney Bender and Pamela E. Klassen
Religion and International Relations Theory,
 edited by Jack Snyder
Religion in America: A Political History,
 Denis Lacorne
Democracy, Islam, and Secularism in Turkey,
 edited by Ahmet T. Kuru and Alfred Stepan
Refiguring the Spiritual: Beuys, Barney, Turrell, Goldsworthy,
 Mark C. Taylor
Tolerance, Democracy, and Sufis in Senegal,
 edited by Mamadou Diouf
*Rewiring the Real: In Conversation with William Gaddis,
 Richard Powers, Mark Danielewski, and Don DeLillo*,
 Mark C. Taylor
Democracy and Islam in Indonesia,
 edited by Mirjam Künkler and Alfred Stepan
Religion, the Secular, and the Politics of Sexual Difference,
 edited by Linell E. Cady and Tracy Fessenden
Boundaries of Toleration,
 edited by Alfred Stepan and Charles Taylor